SLAYING
in
SOUTH ST. LOUIS

SLAYING in SOUTH ST. LOUIS

Justice Denied for Nancy Zanone

VICKI BERGER ERWIN
AND
BRYAN ERWIN

Published by The History Press
Charleston, SC
www.historypress.net

Copyright © 2018 by Vicki Berger Erwin and Bryan Erwin
All rights reserved

Front cover, top left: Zanone family; *top right*: photo by Ed Meyer, *Globe-Democrat* Collection, St. Louis Mercantile Library; *bottom*: photo by Paul Hodges, *Globe-Democrat* Collection, St. Louis Mercantile Library.
Back cover, top: Zanone family; *middle*: photo by Paul Hodges, *Globe-Democrat* Collection, St. Louis Mercantile Library; *bottom*: Zanone family.

First published 2018

Manufactured in the United States

ISBN 9781625859068

Library of Congress Control Number: 2017960107

Notice: The information in this book is true and complete to the best of our knowledge. It is offered without guarantee on the part of the authors or The History Press. The authors and The History Press disclaim all liability in connection with the use of this book.

All rights reserved. No part of this book may be reproduced or transmitted in any form whatsoever without prior written permission from the publisher except in the case of brief quotations embodied in critical articles and reviews.

CONTENTS

Foreword, by David Zanone	7
Acknowledgments	9
Introduction	11
1. Nancy	13
2. Joe	37
3. A Murderer Strikes	47
4. Tracking a Killer	51
5. Cracks in the Juvenile System	61
6. Pretrial and the First Trial	65
7. The Second Trial	69
8. Appeal #1	81
9. Trial #3	87
10. The Victims	97
11. The Second Appeal	101
12. A Sister Goes to Work	105
13. And Then Joe…	115
Epilogue, by David Zanone	129
Bibliography	133
Index	139
About the Authors	143

FOREWORD

On December 2, 1963, Joseph Arbeiter walked into our house through the front door and murdered our mother, Nancy Zanone. Our family entered irreversibly into a selective fraternity that nobody seeks: surviving relative of a loved murder victim. It is an experience from which one never fully recovers, a scar that remains suppressed as a dull, lingering emptiness. You want revenge. You settle for justice. In our case, we got neither.

After the shock wore off, the adults in the family handled the aftermath of unexpected death the way people did in those days. Aunts, uncles and grandparents all seemed to retreat into their own silos of quiet grief, a sort of unspoken pact of mutual silence. They rarely spoke about her, especially to the children, as if the memory of her life and the pain invoked by the memory of her tragic death were inseparable. So, the adults smiled as much as they could and pretended everything was okay—except it wasn't. For the children in the family, especially for my sister and me, this silence was both noticeable and confusing, and although no one specifically told us not to, we were reluctant to mention our mother. In our minds, we were somehow responsible for the adults' emotional well-being, especially that of our dad, and we feared that speaking of her would only upset them. My sister and cousin sometimes secretly hid behind the bed in our cousin's bedroom, quietly whispering memories of her to ensure they wouldn't be overheard.

The tangible impact for me was that, as a two-and-a-half-year old, I no longer had a mother. She was there one day, gone the next, and nobody fully explained to me why. With any conscious memory of her fading, until

Foreword

it disappeared, my mother became to me a mythical figure. Only still photos served as evidence she had existed, but a picture has no voice. Photographs are an inadequate surrogate for the real thing.

I also had little comprehension of what actually happened that day; just an allusion here and there. I knew who Joseph Arbeiter was and what he had done and that, somehow, he'd gotten away with it. Why did he kill our mother? Why was he not in prison? What does justice look like? Why didn't we get it? I was naturally curious about the facts and longed for someone to tell me more, but I was afraid to ask. Where was I? What did I see? How aware was I that something had gone horribly wrong that day? I had to have seen something, felt something, but nobody would tell me. That left only a confusing array of seemingly disconnected facts and a blurred recollection of standing next to my sister watching out a window as a black-and-white vehicle, with its sirens blaring, carried our mother away. It never brought her back.

Two childhood dreams hinted at my experience, dreams I'd kept guardedly to myself. In the first dream, I was looking up a long set of stairs surrounded by dark, wood-planked walls, covered by a shadowy roof. I could see my mother sitting at the top of the stairs with the door open, exposing a bright white kitchen above. Then, a faceless figure comes up from behind her with a knife. I can see him raise, then lower, his knife-wielding hand toward my mother's back. I woke in silent panic and heavy breath before the blow struck. In the second dream, I was in the same kitchen doorway, this time looking down those same dark, dreary stairs. My mother is lying at the bottom of the landing with her head propped up against the wall. I look down, feeling only puzzled. I woke up, and she was gone forever.

Life continues a persistent, measured pace forward. We take only brief glimpses back to the path from which we came. Our family was no different as we rebuilt our lives into something for which we can be thankful. Life returned to relative normalcy as years passed and then moved further in the rearview mirror. School, careers, birthdays, weddings and holidays came and went. The anger slowly slipped below the surface, barely detectable, and we've even been able to have a few conversations to learn a little bit about our mother. Bur the aftereffects have never completely subsided. Something is missing, and I have this nagging sense I will never find it. I live with a subtle, yet haunting, unease, trapped between the reality of what is and dreams of what could have been—if only the front door had been locked.

<div style="text-align: right;">David Zanone</div>

ACKNOWLEDGMENTS

Our first words of thanks go to the Zanone family: David, Laura and Don. We recognize that all the questions, the probing, the opening of old wounds was difficult for you. We hope the end result is worth it, and we thank you for all your cooperation.

To Carrie Spencer Gruenenfelder and Julie Gruenenfelder, we thank you for your memories of your mother, Joan Gruenenfelder, and her work to change the juvenile system.

To Brendan Ryan, a thank-you for the wonderful stories of the circuit attorney's office, particularly of your encounter with Joseph Arbeiter. You should write your own book.

To Gary Hummert, thank you for sharing your personal encounters with Joseph Arbeiter in the course of performing your duties with the St. Louis Metropolitan Police Department.

To Amanda Irle, for so patiently and pleasantly answering all our questions and helping us, especially with the technical aspects.

To Nick Fry at the Mercantile Library at the University of Missouri–St. Louis for his research help

To Jim Erwin, for being there, for legal expertise and for just being a great husband and dad.

To Sarah Erwin, for your patience, support and for being a wonderful wife.

INTRODUCTION

I remember the first time I heard about Nancy Zanone. We were planning my sister's wedding to David, and I asked about David's mother. "She was murdered," my sister said.

I was uncommonly silent for a few minutes. "Who? What? How?" I asked finally.

"A kid stabbed her in their apartment. Dave and Laura were there, playing outside."

"Is the guy who did it in prison?"

"He got off."

"How?"

"I don't really know, some kind of technicality. They don't really talk about it."

This was the closest I had ever come to someone who had been murdered. People I knew didn't get murdered. I was a writer and, at the time, wrote mysteries for kids. I immediately began plotting in my head: A young child witnesses a murder; the perpetrator isn't caught or convicted. When the girl is a teenager, the perp shows up again, and she recognizes him. When bad things start happening, she immediately suspects the man who killed her mother. All this was fiction, and I carried it around for a while.

One morning, my husband was reading the newspaper and said, "Here's a story that will affect your family."

I waited for him to tell me who, why, what. And he showed me the news that Joseph Arbeiter was being accused of murder—again. And he was the man who had murdered David's mother in 1963.

Introduction

This case awakened a new need to know on David's part, and Jim helped him secure the trial transcripts of his mother's killer's murder trial(s). It was very emotional when he came to pick up the copies.

Later, David asked if I would be interested in writing his mother's story. He wanted her to be looked at as a person, more than a prop, and he wanted someone to try to explain why there had never been justice for her.

And here we are, trying to make sense of a senseless death, to tell the story of not only the murder of Nancy Zanone, but also the murder of justice.

1
NANCY

Nancy Love stood in the wings of the St. Louis Municipal Opera Theatre, peeking out at the full house. Although she was near terrified at performing on the large outdoor stage, Nancy knew how fortunate she was to be there. It was every St. Louis dancer's desire to tread the boards at the Muny. Older dancers kept asking her if she was planning to make dance her career, and she knew already she wasn't. As soon as she married, she would stop dancing. It was the way she'd always imagined it would be—a wedding, a home, a baby. Dance would have no place in that life.

Nancy dabbed at the sweat already running down her face. She didn't want to ruin her makeup. But it was so very hot. She closed her eyes and took a deep breath to calm herself, waiting for those first notes that would drown out the fear and lead her onstage. Even if it wasn't something she wanted to do for the rest of her life, she was thrilled to dance on that famous stage.

Dancing was an important part of Nancy's life throughout her childhood. Although shy in face-to-face interactions, she put those fears aside when dancing in front of an audience. She also had a lovely singing voice and managed to surprise even her friends when she stood up and performed a solo at a high school concert.

Nancy spent her early childhood and elementary school years in Overland, Missouri, a midcounty suburb of St. Louis in what was then the country. Her younger sister Jo (Joan) was a constant companion, although they had slightly different interests. These were the years of World War II, and Nancy's time

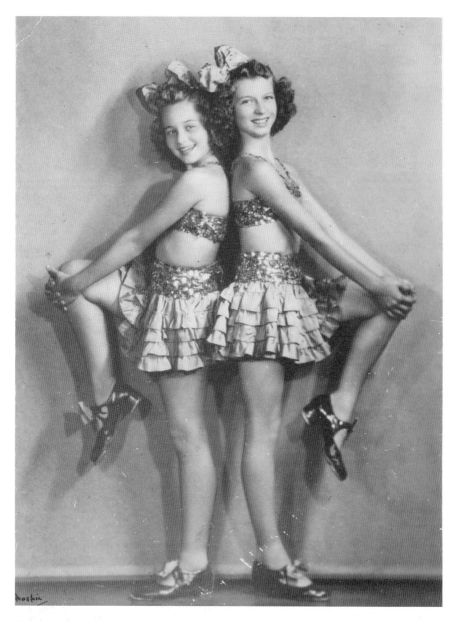

Nancy Zanone (*left*) poses with an unidentified dancer on a postcard for their dance studio. This is approximately the age Nancy was when she appeared at the Muny Opera. *Zanone family*.

Justice Denied for Nancy Zanone

Right: This is the earliest available photograph of Nancy Zanone dancing. *Zanone family*.

Below: Nancy hid her singing ability, so most people were surprised when she performed a solo at a Southwest High School concert. Nancy is at front middle in the white strapless gown. *Zanone family*.

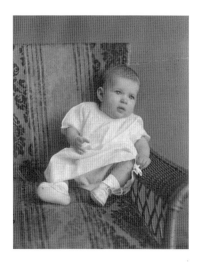

Nancy at three months of age. *Zanone family.*

was subjected to rationing and blackout curtains, like everyone in those days. Her father, fortunately, did not have to fight. He worked for the railroad.

Jo and Nancy's mother, Gladys, loved competitive sports, especially basketball and softball. And she was good. Gladys Love played on a basketball team into middle age and proudly displayed the trophies she and her team (coached by her husband) had won. Nancy half-heartedly participated in sports but preferred dancing. Jo, who wanted to do everything Nancy did, tried dancing but defaulted to competitive sports when dance didn't quite fit her personality. Despite the divergence of interests, the sisters remained very close.

After World War II, a flat opened up in the city, and the Love family packed up and moved. In this new neighborhood, Nancy met (and knew immediately) the person for whom she was willing to give up dance. Don Zanone and his family already lived in the 4900 block of Chippewa in south St. Louis. Like many postwar neighborhoods, the block was full of children and teenagers. The children were allowed to ride bikes and play outside all day in local parks and school playgrounds so long as they were home for supper. Woe to the child who misbehaved! Adults had no qualms about marching a recalcitrant child home to their parents and explaining exactly why they were doing so.

Parents sat outside during the evenings, visiting, drinking beer, eating chips and playing badminton. Everyone in the neighborhood knew one another, including the Zanones and the Loves, although they were not close friends.

The local shops included a grocer, a butcher, a deli, a drugstore and a cleaners. Don worked for twenty-five cents an hour at several of the shops, and Nancy often showed up to chat.

Those local businesses knew and trusted their customers. A parent could send a child to the grocer or butcher with a list, and the merchant would know exactly the brand of food or cut of meat to send home. Purchases were simply added to a tab, no plastic required. The shop owners were also often residents of the neighborhood, living in quarters above their stores.

Left: Nancy at three years of age. *Zanone family*.

Below: Nancy and her sister Joan (Jo) in the front yard of their Overland home. *Zanone family*.

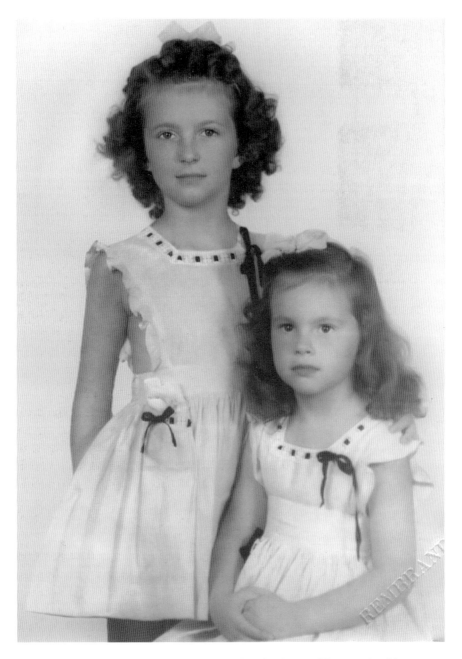

A formal portrait of Nancy and her sister Joan. Despite the age difference, the girls were very close. *Zanone family*.

Nancy continued to dance into young adulthood, until she married. She is in the front row, third from left. *Zanone family*.

Don knew Nancy by name and by sight. When she showed up at his place of work or he ran into her in the neighborhood, they often talked. But he had no idea how interested Nancy was in him or that she was pursuing him. To Don, she was a kid, four years younger, not even in high school. Don was clueless, but Nancy made no secret of her interest. She told people that, someday, she would marry Don Zanone. Even Don's mother referred to Nancy as "that girl who is after your brother" when she and Don's sister Shirley ran into Nancy on the street.

While waiting for Don to notice her, Nancy continued to dance as part of a group that performed throughout the Midwest—Missouri, Illinois, Iowa. On one of her dance trips to Illinois, Nancy was involved in a head-on car collision. She wasn't seriously injured, but it made Nancy extremely nervous to ride in a car, so nervous that she never obtained nor wanted a driver's license.

Her dance career had side benefits. Nancy met her favorite singer and movie actress, Cass Daley, several times. She also met St. Louis Cardinals baseball star Ken Boyer when he played in the minor leagues in Iowa. She impressed Don when she told him that she "knew" Boyer.

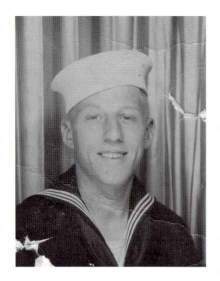

Don Zanone in his navy uniform. He served for four years. *Zanone family*.

When Nancy entered Southwest High School and Don was in junior college, they finally started to casually date. Dates were usually group dates to the drive-in movie or to the Parkmoor, a popular local restaurant/drive-in located in nearby Clayton. Nancy felt much more comfortable in one-on-one settings or in small groups than in a crowd.

Don entered the U.S. Navy when Nancy was still in high school, and they agreed to see other people while he was away. Their long-distance relationship had its ups and downs. Even though they had an agreement, it didn't stop Don from expecting her to be available when he managed to come home. During one leave, he was surprised and disappointed to hear that Nancy was dating someone else and couldn't go out with him—even though she knew he was coming home. What hurt most was that he heard the news from someone else. Nancy hadn't bothered to tell him.

The couple weathered that storm and continued to write to one another and talk on the phone long-distance when Don was in the country, even when Nancy had other boyfriends. In one letter, Don wrote that he was learning to play tennis; Nancy responded by sending him a new tennis racquet, an example of one of the many acts that gradually brought them closer.

In 1953, Nancy graduated from Southwest High School while Don was still in the navy. She was well liked by her fellow students, who agreed that she was the "nicest" and "sweetest" girl they knew. Her feelings for Don were no secret to her classmates; many mentioned him in their yearbook messages to her, hoping they "worked out" and "stayed together."

After high school, still dancing, Nancy went to work at Sinclair Oil, a company that sold heating oil for homes. Her uncle Fred Love was sales manager at the company, and her mother also worked there. Nancy eventually worked her way up to executive assistant to the president of the company.

As time passed, Don and Nancy's romance grew more serious. Nancy even traveled with Don's parents to visit him in Corpus Christi, Texas. The

Nancy continued to date while Don was stationed in faraway places. This photo shows Nancy and an unidentified prom date. *Zanone family.*

Zanones were crazy about Nancy. And it was a good thing, because Don and Nancy were starting to talk seriously about marriage.

Nancy had known ever since she saw him that she wanted to marry Don, and by the time he was discharged from the navy and returned to St. Louis, Don had realized he wanted the same thing. He and his sister Shirley shopped at a local jeweler for a ring.

 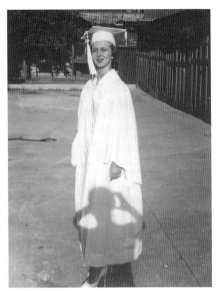

Left: A studio portrait of a teenaged Nancy, signed to Don. *Zanone family*.

Right: Nancy in her graduation robes in 1953 when she graduated from Southwest High School in St. Louis. *Zanone family*.

One evening, early in 1955, Don parked the car and proposed. Nancy quickly answered "yes!"

The two of them had dated for a while and did not see any reason to wait to marry. Don left the planning of the wedding to Nancy, except for the choice of church. He had attended Winona Christian Church until high school, when he had changed to Clifton Heights Presbyterian at an invite from friends. Nancy had no church affiliation before she knew Don. Unfortunately, the Clifton Heights Church was undergoing renovation, so they held the wedding on September 3, 1955, at Fry Memorial Methodist Church. The reception was immediately following at the Gatesworth Hotel on Union Boulevard and included dancing, even though Nancy, a lifelong tap and ballet dancer, was always reluctant to take to the dance floor for social dancing.

After spending the first night of their honeymoon in St. Louis, Nancy and Don spent a week at the Lake of the Ozarks.

The couple settled into a second-floor apartment on Miami Street in the city. Don worked at Skinner and Kennedy, a manufacturer of wall and deskpad calendars, hand fans and donut boxes, all imprinted with custom graphics, while Nancy remained employed at Sinclair Oil.

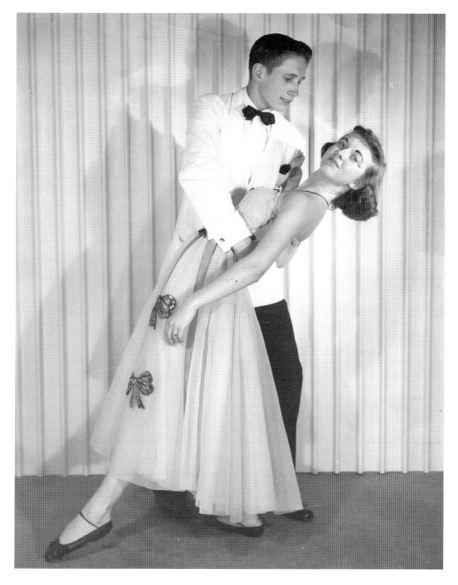

Nancy and an unidentified partner when she was a young adult dancer. *Zanone family*.

Nancy quickly grew even closer to Don's parents. At times, she confided in Mrs. Zanone more easily than with her own mother.

The newlyweds lived a quiet life. Nancy gave up dancing professionally, as she had always planned. Don had loved the baseball Cardinals ever since his days as part of the Knothole Gang (a loosely organized group of kids

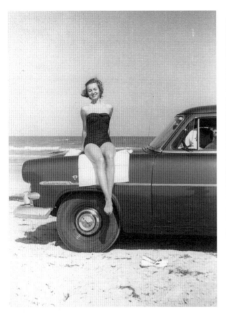 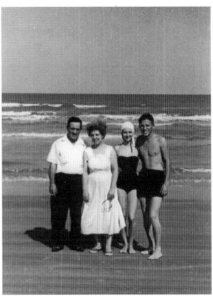

Left: Nancy poses on a Corpus Christi, Texas beach during a visit to Don while he was in the navy. Their romance was growing more serious. *Zanone family*.

Right: Mr. and Mrs. Zanone, Don's parents, traveled with Nancy to visit Don in Corpus Christi. They were very fond of their future daughter-in-law. *Zanone family*.

who watched through the fence or, at certain games, were allowed to watch inside the park for no charge) at Sportsman's Park. Nancy had no interest in baseball but urged Don to continue to attend games while she remained at home and lost herself in a good book.

On Friday nights, they would often join the senior Zanones to watch the Friday night fights on television. Everyone else drank beer while Nancy drank Pepsi. They ate cheese and crackers and smoked cigarettes. Don and his dad would bet a quarter on the fighters, determining who bet on which fighter by the side of the sofa they sat on. Neither knew anything about the fighters beyond the fact that watching them was a pleasant way to spend an evening.

The young Zanones socialized with other couples, especially Nancy's sister Jo and her husband, Tom. The sisters remained very close.

By this time, Nancy's mother was in the beginning stages of addiction to prescription drugs, with prescriptions from a number of doctors making the problem even more serious. This led to unpredictable and sometimes unreasonable behavior. It also made it difficult to maintain a relationship.

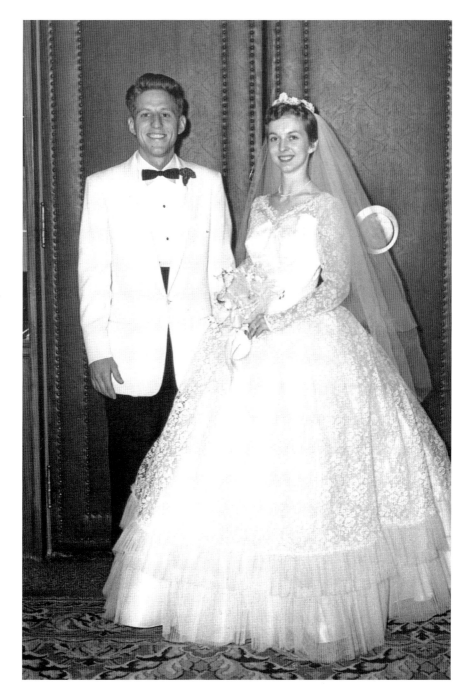

The new Mr. and Mrs. Donald Zanone pose after their wedding. *Zanone family*.

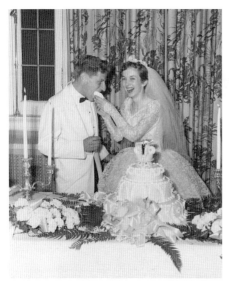
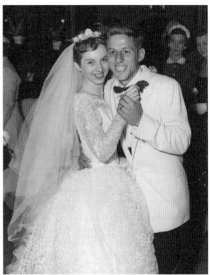

Left: The wedding reception was held at the Gatesworth Hotel. Nancy and Don enjoy a bite of cake. *Zanone family*.

Right: Don and Nancy dance the first dance at their wedding reception. Despite her lifelong involvement in dance, Nancy was very shy about social dancing in public. *Zanone family*.

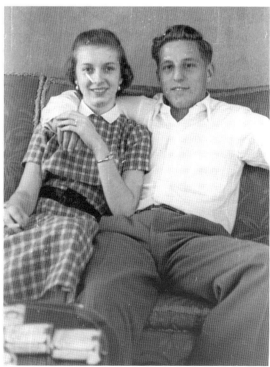

Above: Don, pictured here, was employed at Skinner and Kennedy his entire work career. *Zanone family*.

Right: After Don and Nancy were married, they settled into a second-floor apartment in south St. Louis City. *Zanone family*.

Opposite, bottom: The newlyweds leave for their honeymoon, first at a hotel in the city and then a week at the Lake of the Ozarks. *Zanone family*.

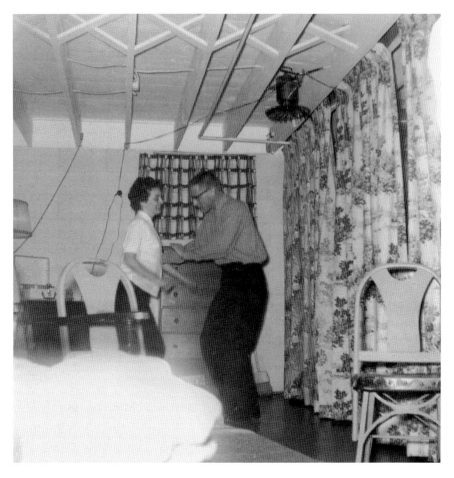

Nancy did not mind having dancing fun with her husband in the privacy of their home. *Zanone family.*

Soon, the Zanone family began to grow. Don and Nancy moved back to the old neighborhood. Their small apartment at 4964 Chippewa was in a brick, four-family flat. Five concrete steps led up to a porch at the front entrance. Directly above the porch was a balcony accessible from the top apartments; brick pillars supported the balcony. The apartment was about a block west of the intersection of Chippewa and Kingshighway, a major intersection in south St. Louis. The Southtown Famous-Barr, a 286,000-square-foot department store featuring a dining deck, coffee shop and a tearoom called the Mississippi Room, sat at the northeast corner of the intersection.

Justice Denied for Nancy Zanone

Baby Laura arrived on February 2, 1958, six weeks prematurely. The pregnancy was difficult, with Nancy developing toxemia in the third trimester. Laura had to remain in the hospital, and Don and Nancy went every day to hold and feed her until she grew big enough and strong enough to come home.

Nancy quit her job and became a stay-at-home mom. The couple were devoted parents. Don loved taking care of the baby as well, rushing home from work each evening to take his turn.

Nancy shared her love of books with Laura (and later David) by reading to her every night. They played outside every day, no matter the weather.

A studio portrait of Laura at approximately age three months. *Zanone family*.

A few years later, on June 27, 1961, David was born. Don took Nancy to the hospital and settled into the waiting room, alone. He waited and waited, with no word. A cleaner came in, looked around and asked, "Are you the only father in here?" Don said he was. "There's a new baby boy in the nursery," she said. "Must be yours." The doctor had forgotten about Don because of complications with the birth.

Everyone, including Laura, was delighted with the new baby. Nancy and Don considered their family complete.

The Loves had moved away by then, easing some of the stress that living so close together had created.

Nancy and Don had a busy life with two young children. Don continued to work at Skinner and Kennedy, and Nancy took care of the children and the house. They were a traditional 1950s–'60s family. There were aunts, uncles and cousins nearby, as well as grandparents and friends. Life was good.

Tragedy struck the nation on Friday, November 22, 1963. President John F. Kennedy was assassinated, plunging the nation into a somber mood even as Christmas approached. Nancy and Jo spent hours on the phone talking about the event, about how sad it was to think about two small children left without a father.

Regardless of the tragedy of losing a president, Christmas was looming. Don and Nancy spent the evening of December 1 discussing what to buy the

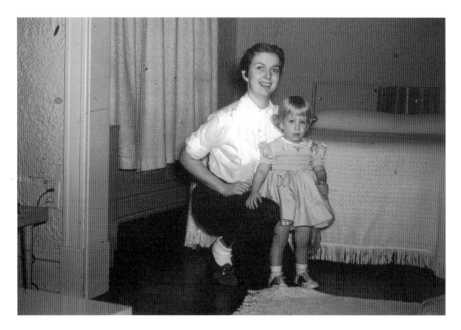

Nancy enjoyed being a stay-at-home mom. Note the shelf of books in the background. She was an avid, lifelong reader. *Zanone family*.

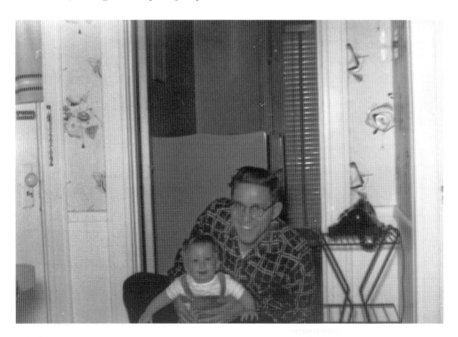

Don was an involved father who spent as much time as he could with his children. *Zanone family*.

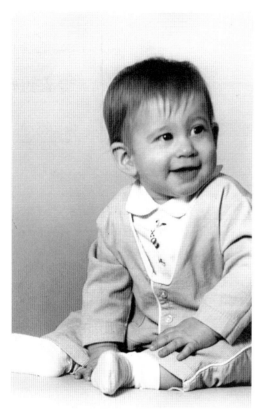

Left: A studio portrait of David at approximately three months. *Zanone family*.

Below: Laura, age three, loved her infant brother. *Zanone family*.

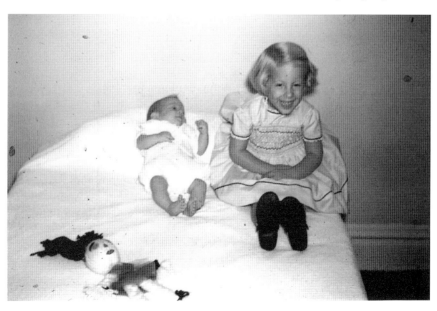

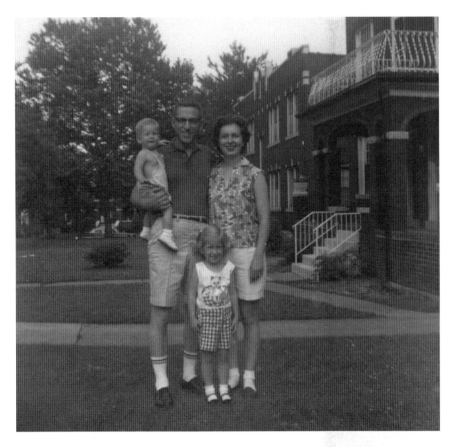

Above: The Zanone family poses in front of the Chippewa house when Laura was age four and David age one. *Zanone family*.

Opposite, top: Nancy and David spend some quality mealtime together. *Zanone family*.

Opposite, bottom: The extended family enjoys a meal together. Clockwise from lower left are Laura, Nancy, Mr. Zanone (Don's father), Mr. Love (Nancy's father), Tom Gruenenfelder (Joan's husband), Joan Gruenenfelder (Nancy's sister), Mrs. Love (Nancy's mother) and Mrs. Zanone (Don's mother). *Zanone family*.

children and making plans to shop. They were also in the market for a house, looking in north St. Louis County for more space for the family.

Monday, December 2 was the end of the long Thanksgiving weekend. The sun rose at 7:01 a.m., just as Don Zanone was leaving for work. Though the temperature had reached fifty-two degrees the day before, December 2 would be much colder, with temperatures failing to reach the forties and wind chills dipping as low as nineteen degrees.

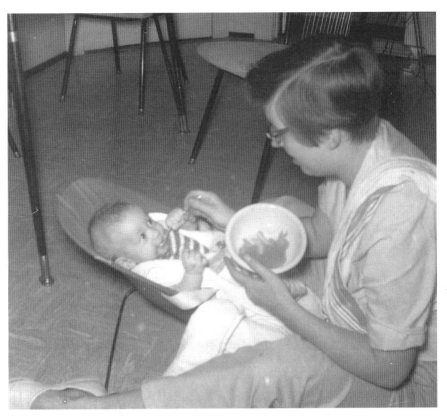

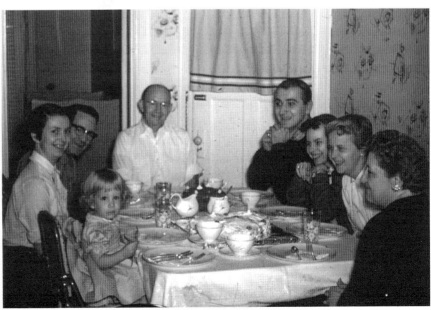

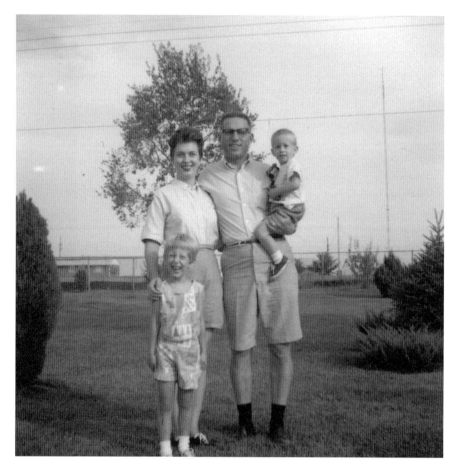

This is the last photo of the four Zanones as a family, in the summer of 1963. *Zanone family*.

As Don was leaving, Nancy was getting their five-year-old daughter, Laura, ready for kindergarten at Buder Elementary School. Nancy still didn't drive; on some days, her mother would take Laura and pick her up. On other days, Nancy and David, now two years old, would walk with Laura to the neighborhood school.

While Laura was at school, Nancy started laundry in the basement laundry room of the Chippewa flat. Nancy spoke with her husband on the phone three times that day, the last time around one o'clock. Grandma Love picked up Laura from school, and they returned to the apartment around midday. When she left the house, Mrs. Love failed to lock the front door behind her.

Nancy still had laundry to finish. With both children home, she got them bundled up in their coats and gloves and sent them into their small backyard to play.

She went downstairs to retrieve clothes, which she then brought up and placed on the ironing board. She laid a shirt on the ironing board, wet her fingers with water and flicked the water onto the shirt. She then ran the iron over the fabric, producing a clean, crisply pressed shirt.

Outside, a stranger, an "old boy," approached the Zanones' backyard. He stopped when he came upon Laura and David.

"Is your mommy home?" he asked.

Laura told him that she was; the boy walked around the side of the building.

Inside, unaware that a stranger had approached her children, their mother returned to the basement of her apartment to check on another load of laundry and prepare more shirts to bring upstairs for ironing. The children continued to play in the yard.

Nancy Zanone paused when she heard footsteps upstairs. The steps sounded too heavy to be her children's.

Nancy put down the laundry and started up the stairs to investigate the noise. When she reached the top of the steps, she pushed the door open.

2
JOE

Joseph Arbeiter shared a name with his father, and there was no bigger influence in his life. Unfortunately, this meant that, as the senior Arbeiter's behavior and mental health deteriorated, so too did his son's.

Concerns about Joe's behavior began early, when he was nine or ten years old. At that age, he began stealing money from relatives and acquaintances. When his parents got divorced and his father was no longer a regular presence in his life, Joe's behavior grew worse. He began to skip school and shoplift, sometimes organizing groups of boys for shoplifting expeditions. Shoplifting soon escalated to burglaries. Joe also became more fascinated with knives, using them as weapons in the home and, on at least one occasion, against strangers.

Arbeiter's parents had met in the early 1940s. His mother, Wilma, moved to St. Louis from Poplar Bluff, Missouri, in 1941 when she was seventeen years old. Having completed three years of high school, she came to the city to seek employment, which she found at the St. Louis Army Ammunition Plant.

The plant had just opened in 1941. Ammunition production began nine days after Pearl Harbor. During World War II, the plant was the largest maker of .30-caliber and .50-caliber ammunition in the world. Half of the plant's workforce were women.

While working at the plant, Wilma met Joseph Arbeiter, a soldier in the U.S. Army. Arbeiter was twenty-five years old in 1941 and already an eight-year veteran of the army. The two were married in University City, Missouri, (a St. Louis suburb) on April 19, 1943.

Slaying in South St. Louis

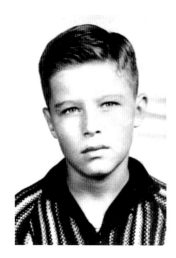

Young Joseph Arbeiter in an undated photo. Globe Democrat Collection, St. Louis Mercantile Library.

Shortly after their wedding, Joseph Arbeiter was sent with the 101st Airborne Division to Germany, where he remained until November 1945. The 101st played a part in several notable events during the war, including the Normandy invasion, the Battle of the Bulge and the liberation of the Kaufering concentration camp.

While Arbeiter's service was distinguished, it also had negative effects on him. When he returned from the war, he began drinking regularly. A social worker who worked with Joe Arbeiter testified that when his father "wasn't drinking he was a good guy. When he was drinking, he was a bad guy."

Arbeiter's first assignment after the war was as an army recruiter, working out of the Mart Building on Spruce Street in downtown St. Louis.

In 1946, the Arbeiters had their first child, a girl. Arbeiter had been promoted to sergeant by then and applied to work as a ROTC instructor at Wentworth Military Academy in Lexington, Missouri. Lexington is a small town on the Missouri River about an hour east of Kansas City. It is most notable as the site of the Civil War Battle of Lexington in 1861.

It was while the Arbeiters lived in Lexington that Joseph Franz Arbeiter Jr. was born. He arrived on June 15, 1948, in Fort Leavenworth, Kansas. Fort Leavenworth is about eighty miles from Lexington; the Arbeiters chose that as the site of Joe's birth because it was the nearest military installation, so the medical care was free.

The family stayed in Lexington for the first three years of Joe's life. Even then, troubles with the elder Arbeiter's drinking were evident. When Joe was two years old, the toddler refused to eat his dinner. His father, drunk at the time, became enraged. Holding Joe's mouth open, his father picked up his son's cup of milk and poured it down his throat, not letting go until he was sure the boy had swallowed it. This kind of abuse was not uncommon in the household.

Incidents such as these, along with the whirlwind series of moves the Arbeiters were about to embark upon, led a social worker who later worked with the junior Joe Arbeiter to testify that "the family background was anything but conducive to a well-adjusted youngster, or adult."

The first of those moves came in 1951, when the senior Arbeiter entered U.S. Army Ranger School at Fort Benning, Georgia. This training also included multiple months of preparation in Denver, Colorado. The family accompanied their father to the Rockies for those months before moving back to Fort Benning.

As Arbeiter was in ranger school (and even before), the Korean War had broken out. He applied to go to Korea and was soon fighting in the war. His service in the war was distinguished. He received a Bronze Star for "heroic achievement as a member of Company E, 38th Infantry Regiment, 2nd Infantry Division, in action on September 9, 1952 in the vicinity of Charwon, North Korea."

According to the declaration, Arbeiter

> *planned, organized and led a five man reconnaissance patrol from "Outpost Yoke" to a point two and one-half miles into enemy territory. After penetrating about nine hundred yards, he decided to halt in a grove of trees and observe the enemy. A short time later, he saw a large group of enemy soldiers gathered in one spot. Without thought of personal safety, he crept forward to an exposed position and called for and adjusted a devastating barrage of mortar and artillery fire on them, killing approximately fifty and wounding many others. Later, he spotted another group of enemy in the same general area. Again he fearlessly exposed himself to enemy observation and called in a deadly curtain of fire, killing twelve of this smaller group. After sunset, he led the patrol to their objective, gathered the necessary information and returned his men to friendly lines without a casualty.*

Less than two weeks later, Arbeiter earned a Silver Star for "gallantry in action…in the vicinity of Hill 266, commonly known as 'Old Baldy', North Korea."

In that instance, Arbeiter,

> *acting as platoon leader of the heavy weapons platoon, was given the mission of supporting his company and other elements of the 2nd Battalion during an assault on Hill 266. After directing the fire of his men in a most superior and effective manner, he, without thought of personal safety, proceeded to move his men and weapons forward, leading them through the fire-swept valley, and emplacing them on a knoll on the east slope of the hill, 'Little Chicago', where they could employ direct fire upon enemy*

> *counter-attacks. After receiving orders to displace further, he again led his men through the rain of fire to new positions. Again, fearlessly and at extreme risk to his life, he made continual personal checks on his men, going to each position and placing the men so that they were afforded a maximum of cover and protection.*

Having served with valor, Arbeiter was transferred to Camp Crawford, near Sapporo, Japan, in 1953. At that time, the family (which now included Joe, his older sister and a younger sister born in 1952) joined him in Japan. Housing was not available at Camp Crawford, so the children and their mother stayed at Misawa Air Force Base. Although in the same country, Misawa was not close to Camp Crawford. Joe's father was stationed on the island of Hokkaido, while Misawa Air Force Base is on the Japanese mainland. It was a flight of forty-five minutes to an hour to travel from one location to the other.

The Arbeiter family eventually secured housing at Camp Crawford and made one more stop in Japan, moving to Sendai. During this time, Joe started school on the base. He was not a good student; in fact, he failed kindergarten.

In 1955, the family moved back to Lexington, where they stayed for just over a year and a half. At that point, they moved to Germany, remaining there for close to four years. Their first stop in Germany was Ulm, followed by Bad Tölz, then Munich.

It was in Germany that Arbeiter first began to show signs of acting out. The small thefts began there, including stealing from stores. This also began Joe's days of truancy.

There was growing trouble in the Arbeiter home as well during this period. Joe Sr.'s drinking and associated cruelty continued. On a snowy night in Lexington, the Arbeiter children forgot to take out the trash, one of their household chores. Joe's father discovered this upon returning home from a night of drinking. He woke up the children and forced them to take the trash out without putting on their shoes to protect against the cold.

Soon, the abuse escalated beyond mere cruelty. Joseph beat his wife, often in front of the children. He beat the children, too; Joe was knocked to the floor and kicked in the mouth in view of the other children.

Despite this, Joe seemed to idolize his father. He was proud of his father's military service; Joe was obsessed with the army and knives for much of his life. At various times, he aspired to go to West Point and follow in his father's military footsteps. Bizarrely, Joe's pride in his father extended even to the

beatings that Joe received. He was known to show his bruises to kids at his school and tell them his father had given them to him.

The Arbeiters returned to the United States in January 1960, first returning to Fort Benning, then quickly moving to Eglin Air Force Base in the Florida Panhandle.

After four months in Florida, the children and their mother made their final move—but without Joe's father. The senior Arbeiter had been sent to Walter Reed Hospital for psychiatric evaluation.

The reason for the family's separation from Joseph Sr. was disturbing. At some time during their stay in Germany, the father had begun sexually abusing his two daughters. Joe witnessed these actions; his father admonished him not to tell his mother. After returning to the States, when Wilma Arbeiter learned of the abuse, she reported her husband to army authorities. He threatened to throw acid in his wife's face. It was at that point that Arbeiter was sent to Walter Reed Hospital. Eventually, he was allowed to retire from the military with the understanding that he would never serve again.

The charges against Joseph Sr. were dropped. Wilma Arbeiter did not want her girls to have to testify against him and relive the assaults. She did, however, file for divorce from Joseph. That was granted on April 19, 1961. The divorce left Joe in a home with his mother and two sisters. This was unfortunate, because Joe blamed his mothers and sisters for the divorce while denying his father's role in the breakup. The lack of a male figure became an important detriment to his development.

His mother claimed that she didn't think Joe "liked us [she and her daughters] too much." Joe often cried in bed at night because he wanted to be with his father. He began skipping school with more frequency, at one point failing to attend school for six consecutive weeks, all the while saying he wanted to live with his father. At some point, Joe's father evidently told his son that if he gave his mother enough trouble, he would be able to come live with his father.

Nonetheless, Joe stayed with his mother. She found work at the Alligator Coat Company, making around forty-four dollars a week. She worked long hours, generally from seven in the morning until six at night, which meant that Joe's older sister was often considered "in charge" at home.

During this time, Joe's own behavior escalated. He skipped school constantly. On some of these instances, he would sit in front of the TV and watch *Divorce Court*. On others, he would roam the neighborhood. He was twice arrested for shoplifting from the Famous-Barr department

store located a few blocks from his home on Morganford Road. He was never convicted or otherwise legally punished for these incidents. On both occasions, he was released to his mother. He professed his innocence to his mother; when she did not believe him, he cried. Within the home, he was punished with whippings and restrictions, which had little effect.

Joe became more violent at home. His living situation—the only male with three women—was problematic for Arbeiter. Women produced anxiety in him, likely stemming from his witnessing his father's assaults on his sisters. His threatening behavior could be triggered by being called "selfish like his father." He would tense up and double up his fist at his mother, but he never physically attacked her. His anger, instead, was directed at his sisters.

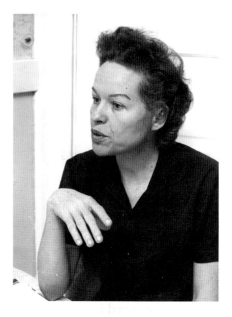

Wilma Arbeiter, Joe's mother. *Photo by Rich Kure,* Globe-Democrat *Collection, St. Louis Mercantile Library.*

In one incident, his older sister refused to iron a pair of pants for him. He lashed out, throwing a fishbowl at her. She required two stitches. During confrontations, he would tell his sisters that "if he could, he would" cut them with a knife. He came close to following through at least once. During an argument, he chased one of his sisters into the bathroom. When she closed the door to keep him out, he retrieved a knife and repeatedly stabbed the door.

His mother began taking him to family and children's services late in 1961, presenting his main issue as truancy from school. His counselor sent him for psychological testing, which showed that Joe "deviated substantially from the norm." His impulse control "was very limited and very decidedly getting worse." Family and children's services felt that Joe should be removed from his home environment for "residential treatment" in a foster home or an institution. This treatment never happened.

Whether the lack of follow-through for Arbeiter's treatment was a failing of family and children's services or of his mother is debatable. Arbeiter did not regularly attend sessions. Instead, he would appear in times of crisis but

stay away when things seemed to be going well. Much of his therapy was directed toward getting more therapy.

As those he saw at family and children's services soon found out, Joe's problems at this time went well beyond truancy. That continued, of course, as well as Joe's burglaries on the days he skipped school. Between February and November 1963, Arbeiter was arrested three times for burglaries and thefts. He confessed to fourteen burglaries, all but three of which took place in homes.

He also continued to have a fascination with knives. Joe even kept a combat knife in his locker at school. Other students knew about his knife, but the teachers did not. He told a psychologist that his nickname was "Dirk," for a type of long dagger. He nearly always had a knife on him. Arbeiter claimed (though unverified) that he once used a knife to defend himself from a gang of boys who attacked him outside of a movie theater. He said he cut the leader of the group, though he did not know how severe of an injury he inflicted.

Arbeiter's first documented case of violence against someone outside of his family occurred in the early-morning hours of Thanksgiving Day 1963. He attended a movie at the Avalon Theater the evening of November 27. When the movie ended at 11:45 p.m., he began walking back to his house on Morganford Road. On the way, he decided to stop for a soda at a drugstore at the corner of Morganford and Beethoven Avenue, about a block and a half from his home.

He arrived at the corner around 12:15 a.m. He paused as he stepped toward the entrance of the drugstore. Grace Munyon, a thirty-one-year-old woman who lived on Beethoven, caught his eye as she walked toward her home. Rather than enter the store to get the soda, Arbeiter decided to follow Munyon and grab her purse.

Arbeiter reached for his keychain, which was attached to his belt. He slid a pocketknife off the keychain and opened the largest blade on it, then slid the knife, blade extended, into his coat pocket. He ran toward Munyon, grabbing her arm from behind while pulling the pocketknife from his coat. Munyon turned toward Arbeiter and struggled to free herself from his grasp. Rather than reach for her purse, Arbeiter thrust the knife toward her, stabbing her in the arm and shoulder.

Munyon shouted "God damn you!" Arbeiter ran away, retreating back to his home.

On that cold December 2, Joseph Arbeiter, in his freshman year at Cleveland High School, had decided not to attend school. In fact, Arbeiter had not attended school since November 17. Joe was bright—his classes

Joseph Arbeiter's freshman class photo from Cleveland High School. Arbeiter (second from left, top row) rarely attended school. *Cleveland High School Yearbook, 1962.*

were Track I, the highest academic grouping. Yet, he was failing English, history and algebra and had a C in biology. He was considered a "loner" at school and belonged to no groups or clubs. The school had sent a postcard to his home notifying his mother that Joe had not been in school; the card was returned with a note that read "sick."

Joe had spent most of those days at his home at 4327 Morganford Road, a brick, rectangular, two-story flat joined to 4329 Morganford. The apartment sat directly across the street from Oak Hill Elementary School, just under a mile from the Zanone home on Chippewa.

Arbeiter's mother left for work that day around 7:30 a.m., while Joe was ostensibly getting ready for school. Instead, he stayed home, not leaving the apartment until later in the day, when he decided to walk around the neighborhood.

Arbeiter was not out for a walk simply for the fresh air. He carried a large knife, of the type used in the armed forces, in a scabbard, which he then tucked under his belt. He had taken "walks" like this before, with the intention of entering homes and taking money. Those homes had previously been unoccupied, though his attack on Grace Munyon earlier in the week suggests that his behavior was beginning to escalate toward more violent confrontations with his victims.

He began his walk by going down an alley behind his house, then he continued through a coal yard and the Famous-Barr parking lot to reach Kingshighway. He crossed Kingshighway and traveled up an alley on the south side of Chippewa.

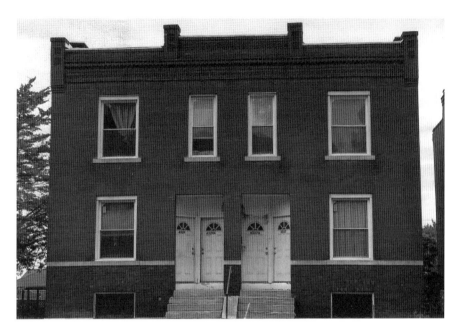

Joseph Arbeiter's home as it appears today. The Arbeiter family lived on the right side of the two-story flat on Morganford Road. *Author photo.*

Arbeiter saw some children playing in a backyard and stopped. "Is your mommy home?" he asked.

The little girl said she was, and Arbeiter walked around the side of the house.

Arbeiter's next stop was the home of Ethel Duff, who lived next door to the Zanones at 4966 Chippewa. He rang the doorbell.

Duff, an older woman with thin gray hair and tinted glasses, answered her doorbell. Their interaction was brief. Arbeiter asked if she had received any mail intended for someone else, a ruse he used in the event someone answered the door.

Mrs. Duff, of course, answered "no." Having gotten the answer he expected, Joseph Arbeiter proceeded west on Chippewa, away from the flat. At some point, possibly after he was satisfied that Ethel Duff was no longer watching, he doubled back to the east and climbed the steps to the Zanones' front porch. The screen door was open, but the wooden front door was closed. Arbeiter rang the doorbell and then knocked on the door. With Nancy downstairs and the children outside playing, no one answered.

Arbeiter tested the door; it was unlocked, so he walked into the apartment. He stepped through the living room and kitchen into the back bedroom. There, he later said, he began to search the room for money.

He moved to the kitchen and heard footsteps coming up the basement stairs. Joe ducked behind the door.

3

A MURDERER STRIKES

Joe reached into his belt and pulled his knife from its scabbard.

Nancy Zanone shut the door and came face to face with a strange teenage boy. He wasn't much bigger than she was, between five feet, two inches and five feet, five inches and weighing between 110 and 120 pounds. Initially, she said nothing and stared at Arbeiter, probably trying to comprehend why a teenager holding a knife was in her kitchen.

Arbeiter struck out with the knife, stabbing Zanone. In his confession, Arbeiter said he stabbed her in the stomach. Dr. Thomas Meirink, the emergency room doctor at City Hospital, where Nancy Zanone was taken, testified that the wound was in the middle of her back on the left side.

When Arbeiter removed the knife, Nancy grabbed at the wound and turned away, screaming. She reached for the doorknob, trying to get away from her attacker.

He was not ready to let her escape. Arbeiter twisted the knife in his hand to point it downward, then plunged the knife into Nancy's back between the base of her neck and her left shoulder blade.

Nancy staggered toward the back door of the apartment, shouting for her neighbor, Betty Thomas, who lived in the apartment above the Zanones, to call the police. Nancy fell to the floor on the landing outside her back door.

Arbeiter headed in the opposite direction, running out of the front door of the apartment, back on to Chippewa. He turned right from the front door, toward Kingshighway. He ran across Lawn Avenue, a one-block street connecting Chippewa to Winona Avenue, and continued in a southeast direction.

Arbeiter crossed Kingshighway and went through the Famous-Barr parking lot on the south side of Chippewa. There was a fence between that parking lot and the soccer fields that belonged to St. Mary Magdalen Church. The church stood on the west side of Kingshighway.

Arbeiter spotted a small pile of loose dirt on the side of the soccer fields. Deciding he needed to hide the knife, Arbeiter hopped the fence. He knelt down by the pile and pulled the blood-soaked knife from its case.

Arbeiter stabbed the murder weapon into the cold ground and twisted, loosening the dirt further until he was able to dig a small hole. Once the hole was deep enough, Arbeiter removed the sheath from his belt and placed the knife inside. He dropped the weapon into the hole and covered it with dirt. Standing up, he swept his feet over the rough covering of the hole, smoothing it out so it would blend in with its surroundings.

He then proceeded back to his home, arriving before his sister returned from school.

At 4964 Chippewa, Nancy Zanone laid on the floor of her back porch. Her daughter, Laura, unaware of what had transpired, went into the house.

"Mommy, can I have a drink of water?" Laura asked. Her mother moaned and again called out for their neighbor to call the police.

Betty Thomas heard Nancy's cries, hurried into her kitchen and dialed the police. Once she notified the police of the attack, she ran down the stairs. By then, Nancy Zanone was unconscious.

Both children had entered the apartment by then and were standing by their mother, screaming. Laura sobbed as she said, "Mommy, please don't die."

Thomas took the children to a next-door neighbor, Margaret McNary. McNary went to Thomas's apartment with the children while Thomas remained with Nancy.

John Kuelker was a decorated veteran St. Louis police officer in the Second District. While on patrol in his police car, Kuelker received a radio call to go to 4964 Chippewa. He was the first officer to arrive on the scene. Kuelker found the front door open and entered the house, proceeding to the back, where Nancy Zanone lay unconscious and, as Kuelker testified, "bleeding badly." He ran back to his car, parked directly in front of the flat and called for an ambulance.

As Kuelker ran out the front door of the apartment, Officer Arthur Von Der Haar arrived, responding to the same radio call. Von Der Haar called for a cruiser, which arrived in a matter of seconds, driven by Officer Paul English.

The officers put Nancy Zanone on a stretcher and carried her to Officer English's cruiser. He then drove Nancy to City Hospital. Dr. Meirink noted that she was in critical condition and in shock, with no blood pressure. Around 3:50 p.m., she was taken to the operating room.

Don Zanone, still at work, received a phone call that something had happened to his wife and that she was in City Hospital. The officers requested permission to ask five-year-old Laura some questions. Don said he preferred to talk to her himself. Laura was able to give her dad a key piece of evidence.

She told her father about her encounter with an "old boy."

"How old do you think the boy was?" Don asked.

"Terry's age," she said. Terry was her fourteen-year-old cousin. Given this age range, the police had a clue that pointed to Joseph Arbeiter.

As soon as the phone call ended, Don rushed to the hospital but was unable to see Nancy as she was in surgery. She remained in surgery throughout the night. In a letter that her father, John Love, wrote to the *St. Louis Globe-Democrat* on January 6, 1964, he said that "the best surgeons worked all night and pumped some 30 units of blood."

Numerous incisions were made during the doctors' work on Nancy. She was given a tracheostomy to allow her to breathe. Tubes were inserted between the second rib and eighth rib on the left side. The tube in the second interspace put in air; the tube in the eighth interspace was to remove blood from the chest.

Officer John Keady of the homicide division and his partner, Eugene O'Donnell, were dispatched to City Hospital to interview Nancy Zanone. When they spoke to her, they found her in a "hysterical state." They asked her who stabbed her, to which she responded, "I don't know." She could not tell the officers whether her assailant was male or female or someone she knew. She could only say, "I don't know. God help me."

Early on the morning of December 3, Don Zanone was finally allowed to see his wife. He held her hand and told her that he loved her. She said the same to him.

Nancy Zanone died at 6:15 a.m., December 3, 1963.

The coroner's report noted penetrating stab wounds near her left shoulder blade and between the seventh and eighth ribs along the "posterior axillary line"—near the back of her lower left side. The second wound penetrated Nancy's lungs and diaphragm, causing extensive hemorrhaging in the pleura, or the thin layers of tissue that protect and cushion the lungs. The first wound caused a laceration of the left subclavian artery and vein, which is under the collarbone.

The coroner stated the cause of death as "Hemorrhagic Shock; Cause penetrating wounds at the superior portion of the thorax, lacerating the subclavian artery and vein. Stab wound of the lower lobe of the left lung."

Laura and David had been taken to their Grandma and Grandpa Zanone's house after eating dinner at a neighbor's home on December 2. The rest of the evening is a blank page in Laura's mind. David, of course, was too young to remember. He always had an impression of looking down at his mother from a height before she was taken away. Until he read the trial transcripts many years later, he had no idea where this mental picture had come from. He had been taken upstairs by a neighbor and stood, until whisked inside, on her back balcony overlooking the scene. After that, throughout his childhood, sirens always invoked fear in him.

When Don finally arrived at his parents' home after Nancy died, he was tasked with telling his children what had happened. He explained that "Mommy went to heaven." Laura's response was, "I'm sorry Mommy died, but I'm glad we still have you." Don cried.

Nancy Zanone was buried on December 4 at Sunset Burial Park. Laura and David did not attend.

Even now, Don refuses to talk about the murder and its aftermath. All the information in this book has been gathered from Laura and David, their surviving cousins, others involved in the case and news reports.

4
TRACKING A KILLER

Captain John Walsh of the St. Louis Metropolitan Police Department was in charge of the investigation into the murder of Nancy Zanone. On the morning of December 3, the night sergeant called Captain Walsh's attention to the stabbing of Grace Munyon on Thanksgiving Day. It was similar to the Zanone attack and near the Zanone residence.

With that information in hand, Captain Walsh called Sergeant Walter Feldmeier of the First District and asked whether he had any suspects in the Munyon case. Sergeant Feldmeier said that he was looking for Joseph Arbeiter, a young man they considered a daytime residence burglar. Captain Walsh suggested that Nancy Zanone had perhaps encountered a prowler in her home who then stabbed her. Sergeant Feldmeier said that was similar to Arbeiter's past history of behavior. The men agreed to keep trying to locate Joe Arbeiter.

Detective Corporal Frank Stocker was dispatched to Cleveland High School to ask after Arbeiter. He was told that Joe had not been at school for over two weeks. Stocker contacted Joe's mother, Wilma, at work. She thought her son was at school. Corporal Stocker requested that she keep Joe at home that evening so the police could stop by and talk to him.

Shortly after Nancy Zanone's death, Officers Keady and O'Donnell were canvassing the neighborhood of the stabbing, looking for potential witnesses who might have noticed someone around the Zanone home the previous afternoon.

Corporal Stocker was also patrolling the neighborhood and, around noon, spotted Joe Arbeiter at the corner of Morganford and Bingham, not far from his house. Stocker stopped his police car and invited Joe to come with him. Arbeiter was taken to the First District police station for questioning. An article in the *St. Louis Post-Dispatch* described Arbeiter as "nonchalant" about this development.

The decision to take Arbeiter to the station instead of immediately contacting and turning him over to a juvenile officer would turn out to be a pivotal one.

While this would prove to be a mistake on Stocker's part, it was in keeping with St. Louis Police Department policy. At the time, police would "question youths taken into custody, conduct an investigation and book them on a special form before turning suspects over to the Juvenile Detention Center." Police felt they were within the law to confirm a juvenile as a suspect before transferring them to the juvenile court.

When Stocker and Arbeiter arrived at the police station, Sergeant Feldmeier, who was Stocker's supervisor, took over the questioning. Even though Captain Walsh had suggested to Feldmeier that Joe Arbeiter might be a suspect in both the Munyon stabbing and the murder of Nancy Zanone, Feldmeier and Stocker insisted that they were mainly interested in the teen for a series of house burglaries. When asked about them, Arbeiter denied being involved. The officers changed their direction and asked Joe how he had spent his previous evenings. He said he had been at the Avalon Theater on the night of November 28. Sergeant Feldmeier asked Joe whether he had stabbed Grace Munyon that night. Arbeiter readily admitted that he had stabbed Munyon. He claimed he "did not think he could hurt her because she was wearing a heavy coat."

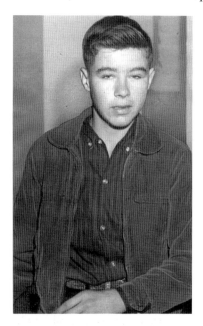

Joseph Arbeiter at St. Louis Police Headquarters after he was arrested for the murder of Nancy Zanone on December 3, 1963. Globe-Democrat Collection, *St. Louis Mercantile Library*.

The officers then turned their questions to the stabbing of Nancy Zanone, asking if Arbeiter had been anywhere near the

Zanone residence that day. Arbeiter initially told officers that on December 2 he was "home all day working on my models."

His interrogators then told Arbeiter that they had information he was seen walking on Chippewa west of Kingshighway the previous day. The detectives noted in their report a "reaction in Joseph Arbeiter's emotions." Jumping on this, they then told Arbeiter they were going to bring in a witness who had seen him on the front steps of a home on Chippewa west of Kingshighway. This was, in fact, not true. Sergeant Feldmeier said in his testimony this was "a ruse commonly used under the law."

Although it wasn't true, the threat had a noticeable effect on Arbeiter. Officers noted that he "registered an emotional disturbance momentarily." Arbeiter then told the officers that he had a basketball game that night at Vashon High School. "If I tell you all what happened could I be turned over to my mother so I could play in that game tonight?" Arbeiter asked.

"Joe, we cannot promise you anything, you know that," Feldmeier said. "So why don't you get yourself cleaned up and get everything off your mind?"

"Well, I may as well tell you all about it, as I did not sleep last night thinking about it," Arbeiter said.

Arbeiter then began his initial confession to Feldmeier. "I was in that house. The woman caught me in her house, and I was scared, so I stabbed her and ran out."

The confession detailed most of his story. Arbeiter said he had left his house around 10:00 a.m. Given that his attack on Nancy Zanone took place around 3:00 p.m. on a day with subfreezing wind chills, it seems unlikely that Arbeiter wandered the neighborhood for five hours. It would not be unreasonable to conclude that Arbeiter, willfully or not, was inaccurate in the time estimate he gave to police. It should also be noted that Arbeiter did not include his encounter with Laura in the backyard of the Zanone home in his confession. Instead, he told police he simply began knocking on doors once he reached Chippewa. He said he thought he went to two houses prior to the Zanone residence for the purpose of seeing if anyone was home.

Was this brief meeting with two small children insignificant to Arbeiter and thus he omitted it from the recap of his day that he gave to police? Or did he not mention it because it revealed his true intentions that afternoon? Certainly, there are members of the Zanone family who think Arbeiter, perhaps after having a taste of violence from his attack on Grace Munyon a few days earlier, was looking to launch a more violent attack on a young

woman. One could question why, if he knew the children's mother was in the house, he decided to enter it anyway.

But, for the most part, the details remained consistent with what investigators found and what Arbeiter said in later statements. The one difference was that Arbeiter told Feldmeier that after stabbing his knife into the ground repeatedly at the St. Mary Magdalen field, he took the knife home with him and hid it in his garage.

In keeping with department procedure, Sergeant Feldmeier cut off the questioning once Arbeiter confessed to stabbing Nancy (at the time, Arbeiter was unaware that Nancy Zanone had died). Feldmeier then contacted Captain Walsh. Walsh directed Feldmeier and Stocker to take Joe to his home on Morganford. Officers James Haley and Elmer Kraeger were dispatched to pick up Arbeiter's mother, Wilma, from her workplace and meet her son and the detectives at the Arbeiter home.

John Keady and Eugene O'Donnell, the officers assigned to the Zanone case the previous day, were also notified of Joseph Arbeiter's arrest and proceeded to the Arbeiter home.

There is some question about the exact sequence of events at the Arbeiter home. Feldmeier testified that Wilma Arbeiter was present by the time the officers arrived at the home. Keady said she was not there but that officers had been sent to retrieve her and no one entered the home until she arrived.

Wilma Arbeiter testified that when she got to her home, the officers were already inside, talking to her son upstairs. Joseph Arbeiter evidently did not have a key to the home; Wilma Arbeiter testified that the officers had gone to the school that Joseph's older sister Joan attended to get a key from her. In Frank Stocker's testimony, he said that Wilma Arbeiter did not have a key to the apartment and that she was the one to go to her daughter's school for a key, still accompanied by police.

Though the sequence of events is blurry, the meat of the conversation that took place once Wilma Arbeiter arrived is not. She asked the officers, "What has Joe done this time?" An officer told Joseph Arbeiter to tell his mother what he had done.

Again the testimony of Wilma Arbeiter and the police officers varies in detail here; she said Joe did not speak, while Captain Walsh said Joe did. Regardless, someone told Wilma Arbeiter that Joe had "stabbed the lady on Chippewa."

Wilma said, "Oh my God, not the woman who died." This seemed to be the first time that Joe Arbeiter heard that Nancy Zanone had died (it is unclear if he was aware that Captain Walsh and Officers Keady and

O'Donnell were from the homicide division and the implications of their presence). At that point, both Joe and Wilma cried.

The police officers asked Joe about the clothing he was wearing when he stabbed Nancy, and he gave them his jacket. When asked about the knife, Joseph Arbeiter told police that the knife he used to stab Nancy was in the garage. The officers contacted William Storer, a police laboratory chemist, and a department photographer before accompanying Joe to the garage. Joe's mother apparently did not go with the group to the garage.

In the garage, Arbeiter pointed to a hiding place over the door where two knives were kept. One was a hunting knife, seven inches in length. The other was a fourteen-inch butcher knife. Arbeiter told the officers that the butcher knife was the knife he used to stab Nancy Zanone. At least one of the officers did not believe it. The knife Arbeiter held was dull and, detectives said, would not make the kind of wounds that Nancy Zanone suffered. Officer O'Donnell said, "Joe, why don't you tell us the truth about the knife you used."

Evidently, this was all the prompting Arbeiter needed. He then admitted that he had buried the knife at the St. Mary Magdalen soccer field.

The entire group proceeded to the field south of the Famous-Barr parking lot. Along the chain-link fence that separated the field from the parking lot was a fresh mound of dirt. Arbeiter said the knife was buried there. Storer dug into the mound and recovered the knife. He then bagged the knife and took it to the lab.

By now it was 4:00 p.m. Captain Walsh drove Arbeiter to police headquarters downtown at 1200 Clark Avenue. Wilma Arbeiter did not accompany Joe. She testified that she asked to go along but was told "they were taking him to the Juvenile Building and I couldn't go until I contacted the juvenile authorities and got their permission."

When Arbeiter arrived downtown, he was given into the custody of Sergeant Michael Kilroy on the fourth floor of police headquarters. Kilroy was one of the department's juvenile officers but not, in an important distinction, a representative of the circuit court's juvenile office.

Also present at the police headquarters was Quentin Gansloser, the first assistant circuit attorney in the City of St. Louis. Gansloser took a question-and-answer statement from Arbeiter with Kilroy, a stenographer from the circuit attorney's office and Brendan Ryan, an assistant circuit attorney, present. The statement essentially reiterated what Arbeiter had told the police. Ryan said that throughout the interview, Arbeiter "showed no feeling whatsoever. He was a perfect sociopath."

Slaying in South St. Louis

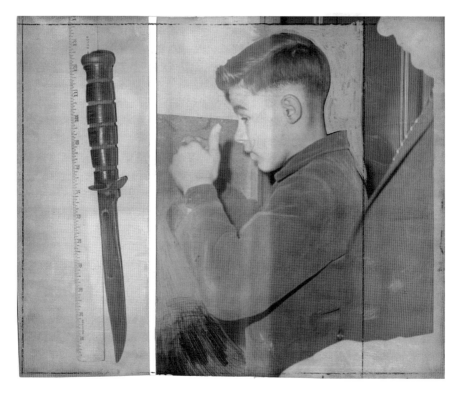

Joseph Arbeiter at the inquest into Nancy Zanone's death. At left is the knife Arbeiter used to stab Nancy Zanone. Globe-Democrat *Collection, St. Louis Mercantile Library.*

Despite this, Gansloser at one point handed the murder weapon to Arbeiter and asked if it was the knife he had used to stab Nancy Zanone. As Arbeiter handled the knife, Ryan thought, "He just killed a woman with that thing—why would you hand him that?"

This statement taken by the attorneys would be a key piece of evidence in the trial that led to Arbeiter's initial conviction. The circumstances of the statement would also be crucial to the appeal of that conviction.

It was only after that statement was taken, now approximately 9:30 p.m., that Arbeiter was finally taken to St. Louis Juvenile Court. He stayed in a ten-by-fifteen-foot room on the third floor of the juvenile detention center that night.

The next afternoon, December 4, shortly after lunch and more than twenty-four hours after Arbeiter was first picked up, he finally spoke with an officer of the juvenile court, Donald Jones.

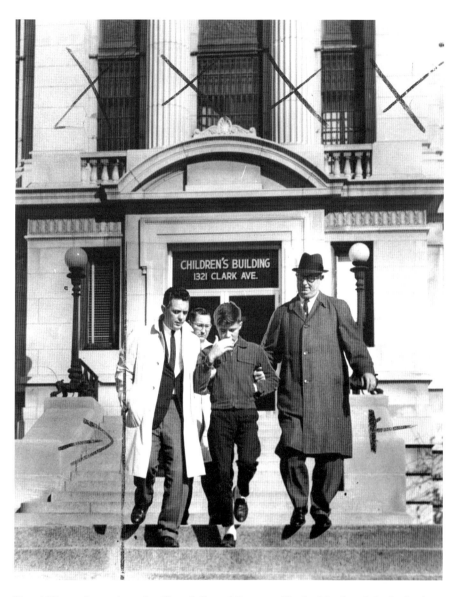

Donald Jones, deputy juvenile officer (left), and Sergeant Charles Mueller of the St. Louis Police Department escort Joseph Arbeiter from the juvenile detention facility. *Photo by Paul Hodges,* Globe-Democrat *Collection, St. Louis Mercantile Library*.

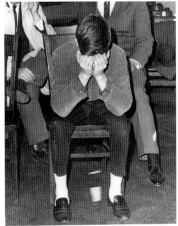

Joseph Arbeiter buries his head in his hands during the December 6, 1963 inquest into Nancy Zanone's murder. *Photo by Paul Hodges,* Globe-Democrat Collection, St. Louis Mercantile Library.

Jones entered a room in the juvenile court building at Thirteenth and Clark. Arbeiter was standing, looking out the window. Jones introduced himself; Arbeiter responded with a meek "hi" in "a very, very low voice."

One of the first things Jones asked was if Arbeiter knew why he was there. Arbeiter responded "yes" and, when asked to elaborate, said, "Because I hurt that woman."

There was a long silence, during which Jones waited for Arbeiter to tell him more, but Arbeiter did not speak. Jones then said, "Joe, what did you do to her?"

"I stabbed her," Arbeiter said.

Jones then said, "Joe, do you know that the woman died?"

Arbeiter said "yes," and again started crying.

Jones took a statement from Arbeiter that became part of a file labeled "Social Investigation." This file consisted of statements from Arbeiter and others throughout Jones's work with him.

The statement is substantially the same as the confession Arbeiter made to Quentin Gansloser the day before: Arbeiter rang the doorbell at the Zanone home, got no answer and went inside. Upon entering the home, he was "surprised by" Nancy Zanone. He pulled the knife that he carried in his belt and stabbed her.

In the statement he gave to Jones, Arbeiter said he stabbed Zanone in the chest, then, when Nancy turned to try to get out of the house and away, he stabbed her twice more. This is a slight variation from what he told Gansloser. In that statement, he said the initial stab was to Zanone's stomach. He mentioned that she turned but did not say she was trying to get away. Arbeiter also told Gansloser that he was unsure if he had stabbed her one additional time or two.

One of the first things Arbeiter asked Jones was to see his mother. Jones informed Arbeiter that visiting hours were Tuesdays, Thursdays and Sundays. December 4 was a Wednesday, so Wilma Arbeiter would not be

permitted to visit that day. Jones did contact Mrs. Arbeiter upon finishing his first interview with Joe to inform her of the visiting hours.

After their first meeting, Jones filed a memorandum with the juvenile court judge stating that Joseph Arbeiter was involved in a violation of the law and requesting that Arbeiter be placed in juvenile detention pending further orders of the court.

Arbeiter remained in the juvenile building downtown for the next month as a judge decided whether he should be tried as an adult for the murder of Nancy Zanone.

5
CRACKS IN THE JUVENILE SYSTEM

Cracks in the St. Louis Juvenile Court became apparent soon after the arrest of Joseph Arbeiter.

Joe had been known to police as a "daytime residence burglar." He had even been arrested once in November 1961 and three times since February 1963 for burglaries and thefts. In July 1963, Joe admitted to committing fourteen burglaries. The outcome of that arrest was to turn him over to his mother to "await disposition of juvenile authorities" or "to appear in juvenile court when notified." The effect was that Joe escaped from punishment. He was never brought before a judge and never received counseling.

Juvenile Court judge David A. McMullan said that the oversight in dealing with Joe was due to the overwhelming caseload faced by an understaffed juvenile court. The court at that time employed twenty-five officers and had 7,000 cases. The court was actually authorized to employ twenty-nine officers, and Judge McMullan said they needed twice as many. He admitted that it was difficult to find qualified applicants, college graduates, willing to work for $5,000 a year. Other states paid up to $7,500 a year for the same job.

"This boy," Judge McMullan said, "should have been seen but wasn't. It's something that we live with 365 days out of the year. We have other boys in the community who should be under supervision and are not because of the terrific case load. We don't have sufficient resources."

Slaying in South St. Louis

Judge David McMullan was serving in the rotating position of juvenile court judge when Joseph Arbeiter was charged with the murder of Nancy Zanone. He made the call to try the juvenile as an adult. *Missouri State Archives.*

Joe's arrest and the attention it brought to the problems in the juvenile system also led to a reassignment of duties among juvenile officers. Ten deputy juvenile officers were assigned exclusively to investigate more serious cases to make sure these juveniles were brought to the attention of the judge. This reassignment had been planned before the Arbeiter case broke but was put on hold pending office space opening up in the Civil Courts Building.

Further information about the interaction—or lack of interaction—between child-oriented social service agencies and the Arbeiter family continued to come to light. Mrs. Arbeiter had asked Family and Children's Services of Greater St. Louis to take over supervision of Joe in January 1962, as he was becoming too much for her to handle. In a four-page letter to the juvenile court, family and children's services recommended, based on test results, that Joe needed "a controlled therapeutic environment." The psychologist who worked with the family suggested that keeping Joe in his home should be tried, but it would "probably be unsuccessful and if so the boy should be removed."

An editorial in the December 9, 1963 *St. Louis Globe-Democrat* addressed how the juvenile court "problem" should be handled. The editorial pointed out that, during 1963, three women had been murdered by teenage boys. Instead of head-shaking and hand-wringing at the heinous acts, the newspaper called for action: lobby the legislature (which set the salary of juvenile officers) and the St. Louis Board of Estimate and Apportionment (which set the size of the juvenile court staff) for more juvenile officers and higher salaries to attract and keep staff. As far back as 1957, the National Council on Crime and Delinquency surveyed St. Louis. The results of that survey suggested a minimum of forty-five officers were needed in the city. The court had twenty-five with four vacancies for a total of twenty-nine

authorized juvenile officers. Nationally, juvenile crime increased 8 percent in 1963 (approximately 601,000 cases), twice the rate of the increase in population aged ten to seventeen years.

The editorial proceeded to give voice to some of the suppositions the community might have: If Joe Arbeiter had been hauled into court when he committed earlier, less-serious crimes, would he have learned that he couldn't "get away with murder?" With family, teachers and family and children's services all aware that Joe had serious problems and needed institutional treatment, could the juvenile court, if it had had adequate personnel and facilities, have saved Joe Arbeiter and, in turn, Nancy Zanone?

Even though Joe's early encounters with the juvenile court had little effect on him, the Joseph Arbeiter case had its own effect on the juvenile justice system in St. Louis City.

6

PRETRIAL AND THE FIRST TRIAL

J uvenile law in Missouri gave the court the ability to certify for trial as an adult anyone over the age of fourteen charged with an offense that would be a felony if committed by an adult. Judge David McMullan of St. Louis Juvenile Court would decide whether that should apply to Arbeiter.

The ramifications were clear; Missouri's juvenile court system ended at the age of twenty-one. If tried as a juvenile, Arbeiter could be incarcerated for no more than six years. If tried as an adult, however, he could be sentenced to life in prison or even death.

An editorial in the *St. Louis Globe-Democrat* published three days after the murder pointed out this difference. That article, which advocated for Arbeiter to be tried as an adult, related that Arbeiter told police "I'm only 15 years old. They can't do anything to me." Although this was not mentioned at either trial, it is a quote repeatedly attributed to Arbeiter by both St. Louis newspapers.

The article also mentioned Arbeiter's earlier arrests for burglary and stealing and stated that juvenile crime could be curbed if the courts "get tough with a juvenile offender the second time he gets involved with the law....An example should be made of Arbeiter which will be so striking and so forceful and so stern and so just that it will be apparent even to the depraved minds of those who will come after him that he paid a horrible penalty for his horrible deed."

As his life unfolded, Arbeiter had incredible good fortune for someone so seemingly undeserving. The first of those strokes of good luck came in the appointment of his defense attorneys.

The idea of a public defender did not exist in 1963. In fact, it was that year that the United States Supreme Court heard the case of *Gideon v. Wainwright*, in which it ruled that the Sixth Amendment gives the defendant the right to an attorney even if the defendant cannot afford one. It was this ruling that ultimately led to the establishment of public defenders; Missouri's system was established in 1972.

Prior to the creation of that office, attorneys were randomly assigned to cases in which defendants did not otherwise have legal representation. Arbeiter's case fell to a firm consisting of four prominent St. Louis attorneys. John Haley Jr. and James Finnegan would represent Arbeiter in his first trial, and were joined by James Williamson and John Bardgett for his second trial. Bardgett was appointed to the Missouri Supreme Court in 1970, eventually serving as the chief justice from 1979 to 1981. The firm would represent Arbeiter throughout the Zanone case.

A closed hearing was held to determine Arbeiter's status for trial. On December 30, McMullan ruled that Arbeiter was "not a proper subject to be dealt with under the provisions of the Juvenile Code" and would be tried as an adult.

McMullan's decision cited several reasons, including "the nature of the crime charged to have been committed; the psychological, psychiatric and social investigation and report; the humane provisions and procedure of Missouri's new Mental Responsibility Act; the limitations on this Court's powers and the more flexible powers of the adult court in meeting this type of case."

The Mental Responsibility Act was a rewriting of state laws dealing with mentally ill defendants in criminal cases, passed only two months before Nancy Zanone was murdered. This act would come into play in the Arbeiter trial, in particular around the responsibility a person had for criminal acts if they had a mental condition at the time of the act. Specifically, the law stated, "A person is not responsible for criminal conduct if at the time of such conduct as the result of mental disease or defect he did not know or appreciate the nature, quality or wrongfulness of his conduct or was incapable of conforming his conduct to the requirements of the law."

It was this last clause—being incapable of conforming conduct to the requirements of the law—that would be brought up at Arbeiter's trial with the testimony of several psychologists and psychiatrists who worked with him.

Arbeiter was officially indicted by a grand jury on January 16, 1964. He was charged with murder in the Nancy Zanone case and, at the same time,

indicted for assault with intent to rob in the Grace Munyon stabbing on Thanksgiving Day.

The Munyon case would play an important role in Arbeiter's first trial attempt. That trial commenced on October 27, 1964. However, on the second day of the proceedings, Sergeant Walter Feldmeier mentioned the Munyon case in his testimony.

John Haley Jr., representing Arbeiter, moved for a mistrial. Judge Casey Walsh agreed, ruling that "higher courts have stated it is a reversible error to have any crime other than the one at issue to be mentioned."

7
THE SECOND TRIAL

The mistrial pushed the date of Arbeiter's trial back about six weeks. On December 7, 1964, his second trial began. David Murphy was the judge; John Bantle, an assistant circuit attorney who would go on to become a judge as well, represented the State of Missouri.

At pretrial, the attorneys and judges conferred on some matters. Chief among those was the admissibility of Arbeiter's statements to police. During the October mistrial, Judge Walsh sustained a defense motion to exclude all of Arbeiter's statements to the police prior to his mother's arrival at their home on December 3, 1963. The defense had requested that all of Arbeiter's statements be excluded, but Judge Walsh overruled the motion in regards to Arbeiter's statements once his mother had spoken with him.

The defense argued that Walsh's ruling should continue into the new trial. Judge Murphy did not agree and overruled the defense's entire motion, including the portion Judge Walsh had kept out of the initial trial. Arbeiter's confession to police would be allowed as evidence in the trial.

Haley also requested a postponement of the case due to an article in the *St. Louis Globe-Democrat* on December 1, six days before the trial. The article mentioned that Arbeiter was also awaiting trial in the Grace Munyon case. Haley said that the Munyon reference and "the statement that the defendant had made certain admissions, having admitted the slaying of Nancy Zanone, having admitted stabbing her with a combat knife, that it would be impossible for the defendant to obtain a fair trial in this court, so soon after the publication of that article."

Judge Murphy overruled the motion; Haley requested the option of renewing the motion at the close of the voir dire examination, stating that, at Arbeiter's previous trial, "ninety-nine percent of the jurors admitted reading, or having formed an opinion from the newspapers, or seeing it on television." Haley also pointed out that the news of Arbeiter's second trial was broadcast on local radio and television stations on November 30 and December 1, the substance of those reports being the same as the *Globe-Democrat* article.

Haley continued to argue that media reports could potentially taint the jury. He moved that the jury be sequestered "for the reason that during the course of the evening and night jurors may have received from the radio, television or newspapers information that will disqualify them, without such fact being known to counsel for defense."

The final motion the defense made prior to the swearing-in of the jury concerned the mention of Nancy Zanone's children, Laura and David. The defense requested that the prosecution not "mention, in his opening statement, or otherwise the fact that Nancy Zanone had two small children, and to instruct the counsel for the State to instruct all witnesses that are called by the State to refrain from any mention of the children of Nancy Zanone, for the reason that it is not relevant to any issue in this case and would be prejudicial to the defense."

Bantle agreed to tell Don Zanone and Betty Thomas (the Zanones' neighbor) not to mention the children in their testimony.

With all pretrial motions complete, the trial itself began with Bantle's opening statement on December 8, 1964, just over a year after the murder.

The prosecution's case laid out the timeline of events on December 2, 1963. Don Zanone, Thomas, the officers called to the scene and the detectives who spoke with Arbeiter on December 3 all testified.

Prior to the testimony of Sergeant Walter Feldmeier, the defense renewed its motion to suppress Arbeiter's confession, which Judge Murphy again overruled. It had been Feldmeier's remark about Arbeiter's attack on Munyon that had caused the initial mistrial. His testimony brought another motion for a mistrial from Arbeiter's defense—Feldmeier testified that Arbeiter told him he "was in that area [of the Zanone apartment on Chippewa] the previous day [December 2, 1963] going from door to door, having in mind burglary."

The defense objected to "any testimony about any other offense the boy may have admitted on this particular day." Since Feldmeier had mentioned that Arbeiter planned to commit burglary, the defense asked a mistrial to be

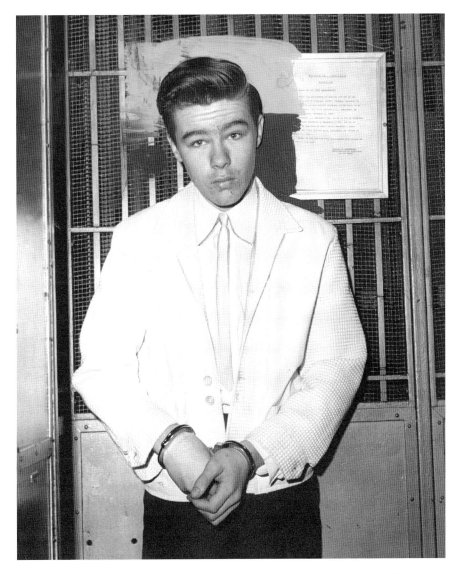

In 1964, Arbeiter was found guilty of first-degree murder in the killing of Nancy Zanone. *Photo by Ed Meyer,* Globe-Democrat *Collection, St. Louis Mercantile Library.*

declared. Murphy overruled the motion and instructed the jury to disregard the mention of Arbeiter's thieving intentions.

The prosecution had another close call during the testimony of Officer John Keady. While neither Don Zanone nor Betty Thomas mentioned the Zanone children in their testimony, Keady made a passing reference to them

(specifically, saying that he "noticed in the children's bedroom, on the wall, were several pictures").

The defense instantly objected, saying Keady "now had injected in the case the fact there were children of the Zanone family, contrary to the Court's instructions to counsel for the State, and contrary to the motion that was made early this morning, there be no mention of these children. It was wholly unnecessary for him to say, 'In the children's bedroom.' He could have left the word 'children' out. We move for a mistrial, because it is prejudicial to the rights of the defendant to inject the children into the case."

Given that Keady was not one of the witnesses the court requested the prosecution to instruct concerning omitting references to the children in their testimony, the judge overruled the request.

The room was referred to as the "back bedroom" in subsequent testimony, and Keady alluded to the children without specifically mentioning them. He described the wall of the bedroom as having "several cut-out Crayola drawings, depicting the holiday season."

Quentin Gansloser, the first assistant circuit attorney who questioned Arbeiter prior to his being handed over to juvenile authorities, gave testimony that consisted almost entirely of reading the confession Arbeiter made to him. The portion of the confession that referenced the Zanone children was omitted from the testimony at the request of the defense.

On cross-examination, the defense established that Gansloser had not advised Arbeiter that he had a right to an attorney or the right to confer with an adult. The trial took place two years prior to the U.S. Supreme Court's *Miranda* decision, though that case ran essentially concurrent with Arbeiter's. Ernesto Miranda's original trial took place in June 1963, so his case would have been on the minds of attorneys at the time, even if the legal precedent had not yet been set.

The defense also questioned Gansloser over whether he had contacted anyone connected to the juvenile court prior to speaking with Arbeiter. It had asked these same questions of every police officer involved in questioning Arbeiter. Each time, the prosecution objected; each time, Judge Murphy sustained the objection.

Dr. John Thomas, a physician in the coroner's office, and Sergeant Michael Kilroy, a police officer assigned to juvenile cases, completed the state's witnesses.

The trial resumed on December 9 with the presentation of the defense. Its first action was to move to strike from the records all evidence related to Arbeiter's confessions. It also asked to strike all evidence that came about

as a result of those confessions—specifically, the knife used to stab Nancy Zanone and the clothes Arbeiter wore on December 2, 1963. Its argument was that the police would never have found these items had they not initially gotten Arbeiter's confession, which led them to his home and, subsequently, the field where the knife was buried.

Judge Murphy overruled the motion to strike as well as the defendant's motion for judgment of acquittal at the close of the state's case, which rested heavily on the confession and all evidence that flowed from it being illegally obtained.

The first witness called by the defense was Wilma Arbeiter, Joe's mother. Her testimony gave the rough outline of Joe's life to the date of the murder. Arbeiter had undeniably had a hard childhood; presumably, this testimony was given in part to elicit sympathy for him, though it also set up much of the later testimony from psychiatrists who had examined him.

In fact, much of the defense case rested on these psychological examinations. Two psychologists, two psychiatrists and a social worker who had talked to Arbeiter (most, but not all, after the murder) were called to testify as to Joe's mental condition.

Jana Haley, the social worker assigned to Joe at the St. Louis Division of Family and Children's Services, was the first to testify. She initially met Arbeiter in late 1961, which was when Arbeiter began regularly skipping school. After hearing of Arbeiter's background, she suggested he undergo psychological testing.

During this testimony, Haley became the first to explicitly mention that Arbeiter was "given to impulsive behavior when under stress." She also brought up another theme that ran through Arbeiter's defense: the all-female environment he was living in being a problem.

Haley recommended that Arbeiter be put in foster care or institutional care, as his home environment "made him tense, very anxiety provoking for him in general." This recommendation had been made to the juvenile court once Arbeiter progressed from mere truancy to stealing while he was not in school. However, neither the court nor the division of family and children's services ever acted on the recommendation.

A key question the defense asked its witnesses was whether Arbeiter's mental state suggested a likelihood of violence toward women and whether he was able to control his actions in all circumstances. Haley stated that she "was quite concerned" and that "he was not totally in control of himself at all times." The psychologist who performed the testing that Jana Haley had requested, Howard Rome, was the next witness called to testify.

Rome had examined Arbeiter on February 17, 1962, giving him several tests: the Wechsler Intelligence Scale and Rorschach, Bender-Gestalt and Thematic Apperception Tests. Rome testified that he "found Joe to be a youngster having a great difficulty to control hostile and angry impulses, having difficulty to the point there were lapses, or breakdown of control, in which he would act in an uncontrollable angry fashion. These were directed primarily toward his mother, in particular, and females, in general."

Rome also said Arbeiter was "a boy of average intelligence, who had possible potential, bright and normal, but his emotional problems were interfering with his performance."

The defense continued to press the issue of Arbeiter's mental state causing him to be unable to control his actions; such a conclusion would cause the jury to find him not guilty. Rome basically agreed with the defense, saying, "I would consider him to be a youngster having a mental defect." He added that, even in 1962, "his ability to control impulses was very limited and very decidedly getting worse." Quoting from his own report on his findings, Rome said, "there are signs a more serious disturbance is on the way if help is not given to him."

Dr. Marshall Rosenberg, a psychologist who first examined Arbeiter on December 4, 1963, as a consultant to the juvenile court, was next to testify. Rosenberg interviewed Arbeiter twice and administered psychological tests, many of them the same tests that Rome had administered to Arbeiter almost two years earlier.

Rosenberg concluded that Arbeiter had

> *a serious thought and perceptual disturbance, mainly he cannot accurately place…reality to the degree other children his age can. Secondly, the boy has gross misperception of women, in the terms of potential danger inherent in women, to the degree in which he might be seriously injured, or even devoured by women. Thirdly, the boy was grossly confused as to his sexual role identity, having many fears about his ability to fit into that role, having many doubts about his ability to be an adequate male. Fourthly, it was my finding the boy was suffering from an extreme degree of emotional stimulation, that is, he was reading an emotional stimulation into situations where none existed. And, lastly, that the boy was suffering from unmet security needs; that he felt very little security in his world…and felt he had no one filling these needs…therefore, he had some very primitive and infantile fears.*

Under cross-examination, Rosenberg described some of the specifics of the tests he performed on Arbeiter. Some of the results were bizarre. Rosenberg noted that Arbeiter "showed marked and morbid deviations from the norm."

For example, Rosenberg mentioned one inkblot card that looks like a winged object (a bird or a butterfly) to 95 percent of people. Arbeiter, however, said the card looked "like a little explosion, or a man with his stomach ripped open."

Indeed, it seemed that most of Arbeiter's answers to the inkblot cards had to do with dangerous animals, knives or guns in some way. Arbeiter told of cards that looked like black widow spiders with butterflies inside and dinosaurs whose heads were bitten off and just starting to grow back.

The Thematic Apperception Test consisted of ten cards that pictured people in various poses. The subject is asked to make up stories about the pictures. Rosenberg said this test was instructive toward finding Arbeiter's "perception of women as extraordinarily aggressive and potentially damaging persons. Other figures in the stories he gave were potentially seen as aggressive, cold, rigid, individuals. Almost every behavior problem involved was one in which they were punishing, attacking or physically hurting the youngster, or the youngster would be requiring something from the mother, which she would be unwilling, or unable to give, which would leave the child abandoned and rejected."

Rosenberg testified that when Arbeiter was surprised by Nancy Zanone in her house on December 2, 1963, he probably "saw in that situation a threat to his existence. I think he anticipated severe, violent, mutilation to him."

The defense continued to build its case for Arbeiter having a mental defect preventing his ability to make a rational decision when confronted in the Zanone home. It called psychiatrist Dr. John Bergmann to the stand.

Bergmann had examined Arbeiter on December 5, 1963. When he asked Arbeiter why he was being detained, Arbeiter told him, "I guess I killed someone." Bergmann said Arbeiter "seemed to be confused about this whole situation. He related the story in a manner as if the entire act were really unreal to him."

Bergmann reached conclusions similar to Rome and Rosenberg. While Bergmann said he "could not put a label on him for a psychotic entity, such as schizophrenia, or organic brain disesase, suffice it to say, this boy is very disturbed emotionally." Like Rome and Rosenberg, Bergmann testified that, under the high-stress situation of encountering Nancy Zanone while intruding in her house, Arbeiter "could not conform his conduct to the law."

Under cross-examination, Bergmann made an explosive conclusion, one that Rosenberg did not state. Bergmann said, "I don't think that Joseph was out to simply burglarize a home. I think this boy was unconsciously, if you please, driven to kill a woman."

Bantle, of course, jumped on this statement.

"You mean he had set out from his home with the unconscious…desire to kill a woman?" Bantle asked.

"I don't think one makes decisions unconsciously."

"I was using your own words. You use your own words to express it."

"I think this boy was impelled in the direction of doing seriously bodily harm to a woman."

"And not what he told you, to find a place there was nobody home, in order to get in and get some money?"

"I don't think this was the only reason. Consciously this might be what Joseph said about this situation, but I think there was so much hostility, and such a disturbance in this sexual area, that this boy was headed in the direction of killing a woman for some time."

Bergmann later recounted that Arbeiter seemed to have little reaction to the crime he committed. "There seemed to be no remorse about it, or really no fears…it was just very blank, and an inappropriate emotional response to this situation."

Dr. Joseph Callahan was the fourth and final medical professional to testify for the defense. His meetings with Arbeiter took place between June and August 1964. He had been hired by the defense team to provide his evaluation of Joe. Callahan had access to the findings of Rome, Rosenberg and Bergmann prior to meeting with Arbeiter and, as to be expected of a defense witness, had findings that were generally in line with those of the prior mental health professionals to testify.

Callahan spoke of "a feeling of insecurity on [Arbeiter's] part. There was a feeling of foreboding, that some catastrophe was going to happen."

While Callahan said that Arbeiter was "a bright youngster" with "good potential," he also spoke of wide shifts in Arbeiter's perception of the world. In a short period, Arbeiter could go from seeming normality to an inability to function. It was because of this that Callahan concluded, like the others, that Arbeiter "presented the type of personality when, at the moment of stress, without question, at that moment he would be considered psychotic. He would be unable to bring into play, to guide his actions to what he might want them to be, or what society might require them to be."

Although the others were not asked, Callahan did provide some insightful comments on the possibility of Arbeiter's condition ever improving. It seems that Callahan was probably accurate when he said, "The outlook is poor. I think treatment is very important. But even with treatment my evaluation is that the outlook is not an encouraging one."

This bit of testimony was intended, of course, to lighten Arbeiter's potential sentence. The line of questioning led to Callahan saying that Arbeiter would function best in a psychiatric hospital, where he could obtain a sustained period of treatment.

After Callahan's testimony, the defense rested its case. The state offered three rebuttal witnesses, focusing on Arbeiter's mental health. Two of the witnesses were psychiatrists, the other a psychologist.

Dr. Daniel Hellman was the director of the Social Maladjustment Unit at Malcolm Bliss Hospital in St. Louis. This division handled all psychiatric examinations of people charged with crimes in the city of St. Louis. In this capacity, Hellman examined Arbeiter in the winter of 1964. Arbeiter was admitted to the hospital on January 29, 1964, and released on February 19.

Hellman gave Arbeiter a diagnosis of a passive-aggressive personality, which he described as "a person who presents a somewhat passive outlook on life, but has bouts of being aggressive at times, especially under frustration or stress." While much of Hellman's diagnosis concurred with those of the defense's doctors, there was a key piece that did not.

The state asked Hellman if he found "any evidence of any mental disease or defect which made Joseph Arbeiter unable to know or appreciate the nature, quality or wrongfulness of his conduct, or rendered him incapable of conforming his conduct to the requirements of law."

"I didn't," Hellman said.

On cross-examination, the defense focused on Hellman not being specifically trained as a child psychologist. Hellman said he had spent six months in child psychiatry training as part of his medical school training but was, by December 1964, in private practice in Florida.

Another point of contention was a meeting that Hellman's division held with all attorneys assigned to the case. The defense attorneys for Arbeiter were not invited. Hellman said that he was not aware that an attorney had been appointed when the meeting was held in February 1964.

Another member of Hellman's team, Mary Grohmann, testified in general agreement with Dr. Hellman. She said: "I did not think the boy was psychotic. I did feel he was quite disturbed…He is emotionally disturbed, but his thinking was not illogical, there was no thought disorder."

The state also had a psychiatrist, Dr. James Haddock, that it requested examine Arbeiter. Haddock did so in late September 1964. Like Hellman and Grohmann, Haddock's findings contradicted those of the doctors the defense had called. "It is my belief that at the time of the crime for which he is accused he did know and appreciate the nature, quality, and wrongfulness of his conduct and was capable of conforming his conduct to the requirements of the law."

The defense produced two rebuttal witnesses. Dr. Callahan retook the stand to provide his view of some of the terms discussed by the prosecution's witnesses. Specifically, he testified about passive-aggressive personality, the difference between an emotional disturbance and a mental disturbance and the age at which child psychiatry ends and adolescent/adult psychiatry begins. James Finnegan, one of Arbeiter's attorneys, also testified on his failure to be invited to the meeting held by Daniel Hellman.

With that, the defense filed its motions for a judgment of acquittal. Included in the motions were a motion for acquittal because "the evidence offered by the State and admitted into evidence by the Court, consisting of or concerning the alleged admissions or alleged confessions of the Defendant and the evidence discovered by the State alleged as a result of such alleged admissions or confessions were erroneously and illegally admitted into evidence by the Court and that the remaining evidence offered by the State is not sufficient to sustain a judgment of conviction of the offense charged."

On the morning of December 11, 1964, after four days of testimony, the case was handed over to the jury. The jury was given four options for a verdict: Arbeiter could be found guilty of murder in the first degree (the charge against him); guilty of murder in the second degree; not guilty of murder in the first degree; or not guilty by reason of a mental disease or defect excluding responsibility.

Instructions were given pertaining to the plea of not guilty by reason of mental disease or defect excluding responsibility. The instructions stated that "the law presumes that the defendant at the time of the conduct charged against him was free of such a mental disease" and stated that the burden of proof pertaining to Arbeiter's mental health at the time of the murder was on the defense.

The instructions also stated that, should Arbeiter be found not guilty due to a mental disease, he would be committed to the director of the Division of Mental Diseases for Missouri. If this happened, Arbeiter would be released "only if and when it was determined that he did not then have and in the reasonable future was not likely to have a mental disease or defect rendering

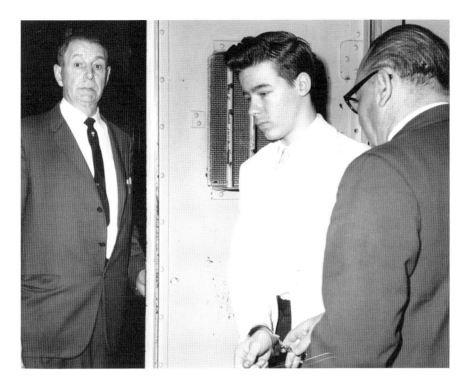

Two unidentified men lead a handcuffed Joseph Arbeiter on the way to his 1964 trial for the murder of Nancy Zanone. *Photo by Ed Meyer,* Globe-Democrat *Collection, St. Louis Mercantile Library.*

him dangerous to the safety of himself or others or unable to conform his conduct to the requirements of law."

If Arbeiter was found guilty of murder in the first degree, the instructions stated that his punishment would be "imprisonment in the penitentiary for and during the remainder of his natural life."

Judge Murphy also instructed the jury that, should they find Arbeiter's mental defect enough to keep him from acting "deliberately" against Nancy Zanone, but not enough to find him not guilty of the crime, they should consider if he was guilty of murder in the second degree. "Deliberately" was defined in the instructions as "done in a cool state of blood. It does not mean brooded over or reflected upon for a week, a day, or an hour, but it means an intent to kill executed by a party in a cool state of the blood, in furtherance of a formed design to gratify a feeling of revenge, or to accomplish some other unlawful purpose, and not under the influence of a violent passion suddenly aroused by some provocation."

The sentence for murder in the second degree, also included in the judge's instructions, would be "imprisonment in the penitentiary for such length of time as you [the jury] deem proper, not less, however, than for ten years."

The jury deliberated for three hours. At 5:34 p.m., the jurors returned to the courtroom with their verdict. Arbeiter was guilty of murder in the first degree and sentenced to life in prison. He was sixteen years old.

Arbeiter did not display any emotion upon the reading of the verdict. His mother wept.

Within five days, Arbeiter's attorneys filed for an extension of time for filing a motion for a new trial. In February 1965, Judge Murphy overruled the motion for a new trial. The attorneys immediately filed notice of their intention to appeal to the Missouri Supreme Court. The grounds for their appeal was that Arbeiter "was not advised of his constitutional rights at the time he made a formal confession and that the statement, therefore, should not have been admitted as evidence in the trial."

8
APPEAL #1

On October 10, 1966, the Missouri Supreme Court reversed Joseph Arbeiter's first-degree murder conviction and sent the case back to be retried. The appeal contended

> *that the defendant was not prior to making such statements (confessing to the police that he stabbed Nancy Zanone), advised of his rights to remain silent, to legal advice, or advice from a competent adult, and was not furnished such advice and, therefore, such statements were not voluntary and such evidence was obtained in violation of defendant's rights under the Juvenile Code of Missouri and under the Fifth, Sixth and Fourteenth Amendments of the Constitution of the United States.*

There was no contention by the state that Joe had been advised of his right to remain silent or his right to consult an attorney or an adult by the police officers. The assistant circuit attorney who took his statement did tell him that the statement could be used against him but did not advise him of his right to remain silent. Today, we are accustomed to a Miranda warning preceding any police action. *Miranda* was decided in 1966. Joe's arrest for the Nancy Zanone murder was in 1963.

Although the issue of constitutional rights was brought up in the appeal, the basis of the court decision was the contention that Joe, a fifteen-year-old juvenile, was not taken "immediately and directly before the juvenile court" or delivered "to the juvenile officer or person acting for him," as required by Missouri statute. Brendan Ryan stated in his interview with the authors that

he and the first assistant circuit attorney believed that the presence of the police juvenile officer fulfilled that requirement.

The underlying philosophy of a juvenile court system is rehabilitation, not punishment. The juvenile court system recognizes that with juvenile offenders, the state has both an opportunity and a responsibility through a noncriminal proceeding to redirect and rehabilitate the juvenile. This is for the benefit of the youthful offender and society.

The court concluded that the juvenile code is "to protect the interests of juveniles rather than to facilitate police investigations." This was in response to the state's argument that turning the juvenile over to juvenile authorities forthwith made it too difficult to investigate the case. The court said that if these special procedures designed to protect juveniles were shown to be adverse to the best interests of society, then it would be up to the legislature to change them.

The juvenile court came under scrutiny even before the Arbeiter decision was handed down. In March 1965, the *St. Louis Post Dispatch* ran an article outlining how juvenile officers still carried an overload of cases. Little had changed since 1963, when the news covered how Arbeiter had never come before the juvenile court, even though he had been arrested several times. Noah Weinstein was juvenile court judge in St. Louis County in 1965 (judges rotated juvenile court duties). He contrasted the six months he spent in the juvenile court in 1956, "a rocking chair job," "with one day a week worth's work," to the same job in 1965, "not enough days in the week." Juvenile delinquency cases in St. Louis County had increased 45 percent over the rate in 1963.

The situation with the juvenile court was equally serious. Juvenile officers, still paid only $5,000 a year, had to make a choice: analyze a case and decide the best way to handle it, or concentrate on proper supervision. Each day, the overworked juvenile officers had to ask themselves, "Were these the cases I should be seeing first? Have I overlooked a Joseph Arbeiter?"

The juvenile court was heavily criticized. Police picked up a juvenile offender, turned them over to the authorities, and the kid was back on the street before the police officer. But where else can the child go? Residential placement facilities were overcrowded; one child had to be released before another could be admitted.

The problem continually circled back to a lack of juvenile officers, especially seasoned officers. The $5,000 salary meant that officers were constantly leaving for better-paying jobs—three left in 1961, four in 1962, eight in 1963 and five in 1964.

(In 2018, the juvenile court is now known as St. Louis City Family/Juvenile Court. There are approximately 220 employees, not all juvenile officers, according to the *City of St. Louis Family Court Report to the Community*. Salaries for juvenile officers start at approximately $36,000.)

The decision in the Arbeiter case, in addition to granting the defendant a new trial, led to changes in police procedure (and arguments about the changes) when arresting and questioning juveniles. The changes were designed to protect the civil rights of the juvenile, according to juvenile court judge Theodore McMillian. He urged the following changes upon the issuance of the court decision: When a juvenile was picked up for any offense except the most minor (truancy or curfew violation, for example), he or she was to be brought immediately to the juvenile detention center. Parents were to be notified, and the juvenile court was to have an officer present during the initial interrogation. This was later interpreted to mean that the juvenile officer, not the police, would question the juvenile. A lawyer would be provided if needed.

The police balked in response to these changes and said before instituting them that they would seek a legal opinion from the city counselor and the circuit attorney. Judge McMillian said the police had no choice in whether or not to change their procedures. The supreme court decision was clear, and if changes were not made and followed, the cases would be thrown out.

The procedure before the court decision was for the police to question juveniles taken into custody at the police station, then investigate and book the suspect on a special form—all before turning him or her over to the Juvenile Detention Center (JDC). The decision whether to keep the suspect in custody or turn the suspect over to parents was made at the JDC.

The police based their procedure on the contention that they could hold the juvenile for a reasonable amount of time to confirm his or her status as a suspect. And the police juvenile officer could be construed as a representative of the juvenile court. (The St. Louis Metropolitan Police Department had specially trained officers to deal with juveniles.) The risk in continuing to follow those procedures was that the case might be thrown out for not turning over the juvenile immediately.

Even before the police decided on whether or not to follow the new procedures, changes were made at the JDC. Personnel were made available on a twenty-four-hour schedule to receive juvenile suspects. Under the old procedures, intake hours at the JDC were 8:30 a.m. to 5:00 p.m.; the police did not bring juvenile suspects in at night despite the statutory requirement that juveniles be turned over to juvenile authorities immediately.

The JDC, new in 1965, held sixty boys and twenty girls. Because of overcrowding, some of the juveniles were housed overnight in police holdover cells. They returned to the JDC each morning for school and recreation.

In November, St. Louis Circuit Attorney James S. Corcoran and City Counselor Thomas F. McGuire issued a joint opinion supporting the juvenile court order that all juveniles charged with an offense be turned over directly to the juvenile court. The new procedures went into effect on November 16, 1965.

The appeal decision also had an effect on a related case. A confession given by fourteen-year-old Carlos Scruggs in the 1966 murder of bus driver Wecter J. Clark in north St. Louis was thrown out. Scruggs and one of his co-defendants confessed that they had participated in the holdup but that their third co-defendant, a thirteen-year-old (too young to be tried as an adult) shot the victim. They made their confessions to the police at the time of their arrest. Circuit judge Robert L. Aronson, ruling on the motion, said he had no choice but to exclude the confessions in light of the Arbeiter decision. "Our Supreme Court ruled that when this statute is violated by the arresting officers, the evidence obtained in the way of admissions by the accused juvenile must not be received in evidence."

Circuit attorney Corcoran tied the decision to the (then) recently decided *Miranda* case, which effectively extended the traditional protections against self-incrimination beyond the courtroom to the police station. He stated that the effect of *Miranda* was to virtually eliminate the confession as admissible evidence. Was the Arbeiter case a juvenile version of *Miranda*?

In response to the Arbeiter case, the St. Louis police announced that they would seek a change in the juvenile code to allow them a reasonable amount of time to question juvenile offenders before turning them over to the juvenile court. One of the reasons for seeking the change was because the police questioned whether the juvenile court officers were sufficiently trained to question youth accused of serious crimes. The department spokesperson said this would lead to lost time if the police could only sit in while the juvenile court officers questioned the suspect. Lieutenant Joseph Phelan of the St. Louis Police Department said the police officers were of more value patrolling than sitting idly in interviews.

A workshop was held at St. Louis University to discuss the effect of the Arbeiter ruling. Approximately 200 police officers, juvenile officers, lawyers and judges attended. The speakers included Judge David A. McMullan (sitting juvenile judge when Arbeiter was charged), Assistant Attorney General Howard McFadden, Boone County prosecuting attorney Frank

Conley, Public Defender William Shaw and St. Louis County prosecuting attorney elect Gene McNary. They agreed that the effect of the Arbeiter decision had been exaggerated. Yes, the case meant greater protection for the rights of the accused juvenile, but it also called for emphasis on using the new and developing scientific methods of investigation and less reliance on the confession as a tool of prosecution. Conley said 85 percent of cases could be solved without a confession and prosecuting attorneys needed to train and work with police to build better cases.

The supreme court ruling had wide-ranging effects—on the police and their handling of juvenile suspects, on the juvenile court itself, on Joseph Arbeiter and on the Zanone family. Joe was granted a new trial, a second chance. And, perhaps without his confession and the related evidence, the prosecution would not be able to make its case against him.

For almost two years following Nancy Zanone's murder, husband Don had lived his life in a fog. Having the murderer in jail provided a slight bit of relief, and life was beginning to take on a new normal.

Don and the children, Laura and David, still lived with Don's parents. The children had a feeling of security with their grandparents, although Laura recalls feeling sad and missing her mother. She would ride around on her bicycle thinking about her. The children were insulated from any talk about the murder by their family as a means of protecting them. However, this was a practice that would later prove troubling to them.

With the case remanded for a new trial, the family—especially Don and Nancy's parents and sister—were faced with reliving the murder a second time.

9

TRIAL #3

The state appealed the Missouri Supreme Court's decision granting Joseph Arbeiter a new trial; the motion was denied on November 13, 1966.

The new trial date was set for January 23, 1967, before Judge Robert Aronson. In preparation, Arbeiter was moved from the state penitentiary back to the St. Louis city jail.

The defense filed a motion to suppress Arbeiter's confession in circuit court on December 19, 1966. Aronson sustained this motion on January 5, 1967, essentially agreeing with the Supreme Court's ruling in vacating the guilty verdict. In response, the state requested that all juvenile court records pertaining to any statements Arbeiter made outside of his formal hearing be made available.

In the motion, the state said that statements Arbeiter made to juvenile court personnel about the murder "would be admissible as evidence, being 'relevant and material' and 'exceptions to the hearsay rule.'"

This motion led to another prolonged court battle. Judge Franklin Reagan granted the motion, issuing a subpoena for the records on March 17, 1967, and setting the trial date for April 17, 1967. Arbeiter's defense team filed a motion to prohibit the subpoena and the opening of Arbeiter's records on March 28, 1967.

The defense's argument was that, under the Missouri Juvenile Code, all files and records of the juvenile court are confidential and privileged, even if the juvenile is certified for trial as an adult, as Arbeiter was. The

opening of the records, the defense argued, "would be in violation of sundry constitutional rights of the juvenile (Federal and State), including due process, the prohibitions against self-incrimination, and the right to counsel."

The motion again went before the Missouri Supreme Court, which ruled in April 1968, more than a year after the motion was filed, that the juvenile records must be turned over to the St. Louis Circuit Court. One justice, Robert Seiler, dissented.

Notable in the court's opinion was that it emphasized that it did "not rule, directly or indirectly, upon the admissibility of any admissions or statements which may conceivably be found in the juvenile records. There will be time for mature consideration of that question when and if any such material is offered."

Reaction to the ruling was mixed. The *Globe-Democrat* applauded the decision, calling it "refreshing." In its editorial, the paper said the most important question was not a lasting impact on Arbeiter but "whether the public should suffer any more delay in bringing Arbeiter to justice."

The *Post-Dispatch*, on the other hand, found the decision to be "questionable public policy." The editorial pointed to Seiler's dissent, which said Arbeiter "had been advised by his lawyer that whatever was said to the juvenile officers could not be used against him in any other place." Even if the admissions in the file were not allowed in the trial, the *Post-Dispatch* said that "permitting the prosecutor to prepare for trial by inspecting material gathered under the circumstances present here surely does violence to the constitutional protection against self-incrimination."

Arbeiter's new trial began on July 31, 1968, with Judge William Buder presiding. Buder was the grandson of Susan Buder, for whom Buder Elementary School, where Laura Zanone attended kindergarten until her mother's death, was named. The prosecutor for the state was Henry Fredericks; Arbeiter's counsel remained the same as at his first trial, but with John Bardgett presenting the case.

Since all of Arbeiter's statements to police were banned and the admissibility of his statements to juvenile authorities had not been ruled upon, it would be a far different trial than his first. Even the charge against Arbeiter was slightly different—the state pursued charges of murder in the second degree, rather than murder in the first degree.

The state relied heavily on the information in the juvenile records. The defense strategy was built around the evidence against Arbeiter being ruled inadmissible; it called no witnesses but vehemently objected to all information

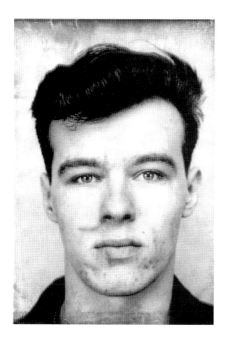

Left: Joseph Arbeiter, now twenty years old, in 1968, prior to being retried for the murder of Nancy Zanone. Globe-Democrat *Collection, St. Louis Mercantile Library*.

Right: John Bardgett was a prominent St. Louis attorney who went on to serve as a circuit court judge before being named to the Missouri Supreme Court in 1972. *Missouri State Archives*.

from the juvenile file. In a way, it was a case built to win not the trial but the appeal that would inevitably follow.

Before the trial even began, Fredericks and Bardgett were at the bench for a long period. Bardgett requested information on what testimony would be given pertaining to Arbeiter's confessions, in this case the confessions he had made to the officer of the juvenile court.

Fredericks said most of it was not in writing and he could give only an oral summary. As soon as he provided that summary, Bardgett issued his first objection toward the admissibility of the confession. Arbeiter's discussion with the juvenile officer, Bardgett argued, was used as evidence in the juvenile court and fell under the provisions of the Missouri Juvenile Code. Therefore, it could not be used for a case in which Arbeiter was tried as an adult.

It turned out to be a wise objection on Bardgett's part, though it would be nearly two years before it bore fruit. At the time, Judge Buder overruled the objection. Buder offered to record that the defense objected to "any and all

evidence" pertaining to Arbeiter's statement to the juvenile officer in order to "expedite and facilitate the trial of this case and avoid undue delay."

Bardgett extended his objection to the state's opening statement, objecting to Fredericks "making any statement in his opening statement to the jury pertaining to any admissions, statements or words uttered by Arbeiter to any person."

Another objection was made, still prior to Fredericks's opening statement. Bardgett wanted to ensure that the knife would not be used, as it was ruled inadmissible due to being discovered as part of the police's illegal interrogation.

Fredericks said he would not show the discovery of the knife but had to say that the stabbing was done with a knife. "He didn't use his finger," Fredericks said. The court told Fredericks he could not say Arbeiter hid the knife, to which the attorney argued, "He didn't leave the knife in her. He didn't leave the knife there."

Judge Buder accepted that argument while also admonishing Fredericks for speaking too loudly when they were supposed to be out of the hearing of the jury.

Fredericks was at last able to begin his opening statement, but even that was interrupted before he made it very far when he mentioned Nancy Zanone's children. Bardgett objected that mentioning the children was "immaterial and prejudicial." When Buder sustained the objection, Fredericks asked to make an offer of proof.

Discussion followed in which Fredericks said he was entitled to show who was present during the course of the events that would be laid out. Nancy Zanone's children were present when she was murdered, and Fredericks argued that he was "entitled to show who was present at the time of the commission of the offense," regardless of their age. "They are as much a part of the scene as her being there dead," he said.

Buder relented and allowed Fredericks to mention the children, while warning him "not to bring in any evidence…which will tend to prejudice or inflame the jury. All it will do, and I am warning you now, will provoke a mistrial."

The state called many of the same witnesses called in the first trial; the testimony of Don Zanone and the officers who responded to the scene was not substantially different from their first statements. In fact, Dr. Thomas Meirink, the emergency room doctor at the hospital who first treated Nancy Zanone, was unable to attend the second trial, so a transcript of his testimony from the first trial was read as a replacement.

Betty Thomas, the Zanones' neighbor, was able to go into a little more detail due to not having restrictions regarding mentioning the children. This allowed her to state that the first thing she did after calling the police was take the children next door. She added the chilling detail that "they were standing there with her screaming."

Sergeant Walter Feldmeier, who took Arbeiter's initial confession to the police, was called to the stand over Bardgett's vehement objections. Bardgett argued that Feldmeier's testimony had already been ruled by the Missouri Supreme Court to be inadmissible.

Fredericks said Feldmeier would not testify as to any statements made by Arbeiter; he was there to show the voluntariness of Arbeiter's later confessions to juvenile authorities. That is, Feldmeier gave a basic timeline of events, using only locations (for example, he first saw Arbeiter at the police station; they then went to Arbeiter's home, etcetera). It was a markedly different testimony than Feldmeier's in-depth accounting of the events of December 3, 1963, in the first trial.

Essentially, Feldmeier testified that no threats were made toward Arbeiter, nothing was promised to Arbeiter in return for him confessing to Nancy Zanone's murder and Arbeiter was not mistreated in any way while in police custody.

Feldmeier did eventually testify to a summary of Arbeiter's statements, though it was under cross-examination by the defense, after it established that Arbeiter was never advised of his right to remain silent or to an attorney. Bardgett also continually referred to the "ruse" that Feldmeier used when questioning Arbeiter—specifically, when Arbeiter asked about being permitted to go to his basketball game that night, Feldmeier told him nothing could be promised, knowing that Arbeiter would not be free to go to his game.

Bardgett revealed his strategy in a discussion at the bench, asserting that after Arbeiter confessed to the police, "the cat is out of the bag; you can't bring it back in the second and the third time." In other words, once Arbeiter confessed to the police, there was no reason not to confess to the juvenile officer as well. Perhaps, Bardgett was hinting, if Arbeiter had been advised to remain silent and had never spoken to the police, he also would never have spoken to the juvenile officer.

Feldmeier later had to return to the stand, as there was a point of contention over a police report he said he used to refresh his memory. Bardgett wanted to see the police report, which was not entered into evidence. Fredericks said it was not necessary, since Feldmeier testified that he did not need to refresh

his memory in regards to the question of whether he promised anything to Arbeiter to get his confession.

The argument over this report became so protracted that even Judge Buder urged the attorneys to "get on with this report business" and that "I think we are attaching…too much importance to it."

Bardgett still persistently pursued the report, saying that it would show that Arbeiter's rights were abused on December 3, 1963, which was contrary to the state's position. Fredericks agreed to read the report from beginning to end; Bardgett did not agree to that, saying instead that he should be entitled to have the report.

This prompted another admonishment from Judge Buder, who told Bardgett he was "being a little unreasonable" and repeated that "we are wasting far too much time on this thing…we have wasted all afternoon with one witness."

After more arguing between Bardgett and Fredericks, Buder continued to vent his frustrations. "If you and Mr. Fredericks enjoy fussing at each other I will bring you here at twelve o'clock tonight and let you fuss until three in the morning," Buder said.

"I'm sitting here very peaceful," Fredericks said.

"Let's get rid of these personalities," Buder said. "You are two high type lawyers and you're wasting your time over trivialities and what you are doing is trying this case over, which was reversed back three or four years ago. Why we get into that I don't know. We are way off the beaten track and it's going to provoke a mistrial now. Gentlemen, it's going to as sure as God made little apples."

Eventually, Fredericks ended up reading the entire document, as he felt that, during the arguments, Bardgett had "stated certain things into the record that have caused me some uneasiness if the record goes to the Supreme Court. And they would wonder just what was in this very secret document that we are trying to keep from everybody, which is really nothing."

The proceedings began the next day with a hearing on the voluntariness of Arbeiter's confession. Testifying first in that hearing was the state's key witness, Donald R. Jones. Jones was the juvenile officer who met with Arbeiter on December 4, 1963, and took Arbeiter's confession within the juvenile system.

The testimony began with Bardgett's objections, stating that "to permit a witness of the juvenile court, serving under, for and under the supervision of the Court, to testify in an adult criminal proceeding against a defendant, who at that time was in juvenile court, would be in violation of the defendant's

rights under the Fourth, Fifth, Sixth and Fourteenth Amendment of the Constitution of the United States, and the applicable provisions of the Missouri Constitution."

The objection was overruled and Jones described his initial interview with Joseph Arbeiter. Arbeiter, Jones said, was withdrawn and downcast. This was a demeanor that Jones said Arbeiter maintained throughout their many conversations. (Jones met with Arbeiter on a daily basis during December 1963.)

When Jones met with Arbeiter, Joe almost instantly confessed, though not in detail. He told Jones that "I hurt that woman" and started crying when Jones asked if Arbeiter was aware that Nancy Zanone had died.

Later in that meeting, Arbeiter gave Jones more of the details of the murder—specifically, that he had rung the bell at the Zanone home and entered when no one answered. He went on to tell him that Zanone had surprised him and that his response was to pull the knife from his belt and stab her.

Under cross-examination, Bardgett pressed Jones on whether he told Arbeiter of his right to remain silent; Jones had not. Bardgett wanted to ask Jones why he had not told him this, saying that Jones would say it was unnecessary since he was an officer of the juvenile court and thus anything Arbeiter said to him would not be admissible if Arbeiter was not tried in juvenile court.

Buder interrupted when he sustained Fredericks's objections to bar those questions. Buder felt that, since the *Miranda* case had not been decided in December 1963 when the events took place, thus putting the Arbeiter case in a "transition period," it was difficult to "separate the wheat from the chaff" as far as what the law was or should have been during that period.

When Jones was dismissed, the defense called witnesses as part of a voluntariness hearing, not as part of the trial per se. Howard Rome, who had reviewed Arbeiter's case at family and children's services, was the first witness called.

Rome's testimony was essentially the same as the one he had given at the first trial. He reviewed each of the psychological tests he had administered and gave his conclusions as to Arbeiter's mental state and perception of the world (as of early 1962) based on those tests.

The defense, in keeping with the voluntariness hearing, did ask for Rome's opinion on how Arbeiter would respond to police officers. When the prosecution objected, the question was generalized to refer to men in uniform.

Rome referred to Arbeiter's admiration of his father and his military service. That, Rome said, could be a factor in Arbeiter's reactions. Rome thought Arbeiter "would be impressed by the uniforms of police officers and probably would be influenced particularly in situations of stress."

The court broke for the day after Wilma Arbeiter testified, primarily on Joe's behavior at home and her interactions with him and the police on December 3, 1963.

Judge Buder began the next day's proceedings determined to make a ruling on the admissibility of Arbeiter's confession to Donald Jones. He repeatedly pointed out that they needed to move the case along and decried the tangents that the previous days of testimony and arguments had taken. "As to whether my ruling is correct or incorrect is probably a matter for higher court, but I am going to enter this ruling," Buder said. "And if the ruling is incorrect, then it certainly should be reversed."

Buder proceeded to rule against the defense, who wished to bar Arbeiter's confession to Jones. Buder ruled that, since Arbeiter had never been tried in juvenile court, the prohibition pertaining to cases tried in that court being carried over to general court did not apply.

Buder also ruled that the *Gault U.S. 1* ruling did not apply to Arbeiter's case. In the Gault case, the United States Supreme Court ruled that, essentially, juveniles were entitled to the same due process rights as adults. This ruling came from the Supreme Court in May 1967.

Buder said that, should the Arbeiter case have been initiated after that date, "there can be no question that the statement…would be wholly and totally inadmissible." But the Gault case did not apply, because it came well after the Arbeiter case.

The defense made several more objections, including to the state calling Officer Michael Kilroy as a witness. Kilroy was a police juvenile officer but was an employee of the St. Louis Police Department, not of the juvenile court. The court again sided with the state, and the trial continued with three more witnesses: Kilroy; Hugh Bobbitt, the intake officer at the juvenile court when Arbeiter arrived; and Donald Jones.

The testimony of the three was riddled with objections from the defense—at times it seemed that the defense objected to nearly every question the state asked. Bardgett maintained that Officer Kilroy should not be allowed as a witness because his role was part of the inadmissible confessions to police, while the juvenile court officers should not be allowed as witnesses because Arbeiter's conversations with the juvenile court should have been ruled inadmissible.

Before his cross-examination of Bobbit, Bardgett stated that he considered it to be "an involuntary cross examination and I am compelled to do so in front of the jury....It is made necessary by the State putting this witness on as a witness and by the Court overruling my objections."

The objections continued when Jones began to detail Arbeiter's confession. The defense argued that this "went beyond what the Court found to be voluntary." The state argued, and Judge Buder agreed, that the court's voluntariness ruling applied to the whole of Arbeiter's statement, not to specific portions of it.

There was a further scrap over whether Jones could reveal that Arbeiter told him that he hid the knife after he fled the Zanone home. After another lengthy discussion, Judge Buder overruled the objection.

At the conclusion of Jones's testimony, the state rested its case. The jury was excused for the evening and instructed to return at 9:30 the next morning to receive instructions from the court and hear closing arguments. These instructions stated the charge against Joe Arbeiter—murder in the second degree—and defined that charge, using the same definitions given in Arbeiter's initial trial. The defense had submitted several instructions to the jury, all having to do with the voluntariness of Arbeiter's confession and that his statements to Donald Jones should be disregarded. Buder refused all of these instructions.

In keeping with the rest of the trial, Fredericks could not get through his closing statement without objections from the defense. Arbeiter entered a plea of not guilty, having withdrawn his earlier plea of not guilty due to mental disease or defect. Fredericks included this information in his closing argument, which Bardgett objected to. Buder sustained this objection.

After reiterating the testimony made during the case, Fredericks made a plea to the jury to consider the impact of the trial beyond this specific case.

"What do we do with him (Arbeiter)?" Fredericks said.

> *I don't say that penitentiary or confinement or whatever the situation may be is best for a person, but sometimes it's the lesser of two evils, isn't it?...Because what Joseph Arbeiter did then and what we do today, is not necessarily to be limited to Joseph Arbeiter, is not necessarily limited to Nancy Zanone in her home, not necessarily limited to this procedure right here and nothing more. We don't ask that you take this young man or any defendant, regardless of his age, regardless of his sex and make an example of him....But we do point out...that the punishment for a crime must be given, should be given, certainly can be given, as a deterrent...to others who*

> *might be so inclined and who may submit similar or think of committing similar such conduct.*
>
> *It goes to deter anybody, so all the Nancy Zanones, not in this city, but everywhere else, certainly have a right to live the kind of life that God expects us to live here, minding our own business, running her own household.... This defendant at the time, and I am sure you will be reminded, was fifteen at the time, and while we don't speak in personal terms against him, we speak in terms against him and his conduct and all others like him and their conduct, because they can destroy just as much as if they were thirty years old.*
>
> *Was it any different to Nancy herself that she was stabbed and cut down by a murderer, by a fifteen year old boy, or one fifty years old? Does it make the wound any less deep?*

The defense waived the transcription of their final argument, so it is unknown exactly what was said, though much of it can be inferred from Fredericks's response.

Bardgett must have made some type of religious allusion; Fredericks said he does not "compare Mrs. Zanone with Holy Mary, but I would say closer to that than Joseph Arbeiter is to Christ. I think that comparison is so ridiculous that there is no need for further comment."

Bardgett also evidently decried the lack of fingerprint evidence and made a statement along the lines of the jury needing to protect the defendant from the mob. The argument apparently made reference to Judge Buder permitting illegal evidence, which was "wrong" and "unfair."

Fredericks repeatedly reminded the jury that their job was to determine the facts of the case. This would clearly work in his favor, since, as he pointed out, the state's evidence was uncontradicted.

The jurors returned with their verdict at 3:25 p.m. that same day. Arbeiter was found guilty of second-degree murder and sentenced to forty years in prison.

Arbeiter was returned to the Missouri State Penitentiary in Jefferson City while the defense team prepared to appeal the case to the Missouri Supreme Court.

10
THE VICTIMS

Laura and David agree that the time between their mother's murder and their father's remarriage in July 1967 was the happiest part of their childhood. They lived with their Zanone grandparents, near their aunt and uncle, Shirley (Don's sister) and Bob Bahn. Their Grandmother Zanone was the closest thing to a mother they remember having. Most important, they felt secure with their extended family. After the murder, there always was—and still is—an emphasis on safety, including making sure doors are always locked.

Don met a woman, started dating and fell in love. The couple decided to marry in July 1967.

Both Don and his new wife had children, so David and Laura joined a blended family. And it was not easy.

Don moved the children, along with the new family, to Hazelwood, a north St. Louis County suburb, across the county from their south county home with their grandparents. David recalls hoping he would finally have a mother, but that never happened—he had a stepmother who blatantly favored her own children. Don agrees that, although she was a good wife, she was not a good mother to his children.

On Mother's Day, then and now, David and Laura missed their mother most of all. Laura felt cheated, and on that day, more than any other, David was very aware of his motherlessness.

In this new family, there was no talk of Nancy and no pictures. Even worse, the extended Zanone and Love families became less and less a part

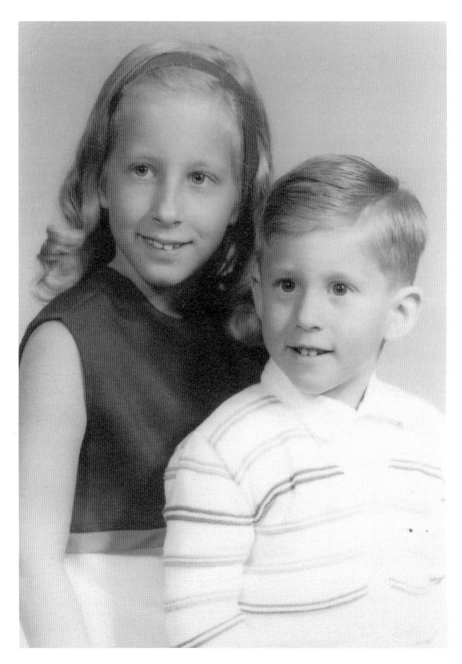

A formal portrait of Laura and David at ages (approximately) eight and five while they were still living with their Zanone grandparents. *Zanone family*.

of their lives as the stepfamily took precedence. It was another loss for Laura and David.

And the second trial loomed. The police had kept Don informed all along. The family had planned a vacation to visit the new Mrs. Zanone's mother in Minnesota. David remembers enjoying these visits and how the stepgrandmother always made them feel welcome. He was looking forward to the trip.

Suddenly, the vacation was delayed with no explanation. Laura and David now realize it was because of the retrial. Still, they only had a vague idea of what had happened to their mother. In that area of their life, the children were still being "protected."

11

THE SECOND APPEAL

On January 12, 1970, Joseph Arbeiter's jury verdict finding him guilty of second-degree murder and sentencing him to forty years in prison was overturned on appeal.

The first trial verdict was thrown out because Arbeiter hadn't been taken "immediately and directly" to the juvenile court. The confession he had given police while in their custody before being turned over to the juvenile court authorities was ruled inadmissible in the second trial.

Judge William Buder, presiding over Arbeiter's trial, himself predicted that the higher court might reverse his decision on the admissibility of Arbeiter's confession to juvenile authorities. Arbeiter's defense team built its strategy for the trial around the idea that the confession would prove inadmissible.

When filed, the appeal Arbeiter's attorneys clearly anticipated was based on both statutory and constitutional grounds.

The statute in question was the Missouri Juvenile Code: "Evidence given in cases under [the juvenile code] is not lawful or proper evidence against the child for any purpose whatever in a civil, criminal or other proceeding except in subsequent cases under [the juvenile code]."

The statements in question taken by Jones, a deputy juvenile officer, were incorporated in a "Social Investigation" report and used by the juvenile court judge (David A. McMullan) to conclude that Arbeiter should be tried as an adult.

The state posited that Arbeiter's statement was voluntary and was not testimony or evidence in a juvenile case, because the juvenile court did not accept the case.

Slaying in South St. Louis

Brendan Ryan was a young assistant circuit attorney in the City of St. Louis when he first encountered Joseph Arbeiter. He made the decision not to retry Arbeiter after his second appeal reversed his conviction based on lack of admissible evidence. *Missouri State Archives.*

In overturning the verdict, the main finding of the Missouri Supreme Court was that it would be unfair to obtain an admission of a juvenile in the non-adversarial atmosphere of the juvenile court and then use that admission against the juvenile in an adversarial criminal proceeding. The role of the juvenile officer is to promote the best interests of the child. Using statements made in the noncriminal, nonpunitive setting of the juvenile court would destroy the court's *parens patriae* (the idea that the government is regarded as the legal protector of citizens unable to protect themselves) relation to the child and be in violation of the noncriminal philosophy that forms the very basis of the juvenile court.

It also rejected the state's contention that the statements were "not evidence in a juvenile case" by deciding that the "jurisdiction of the juvenile court attached from the time that appellant was taken into custody." A petition was filed in juvenile court, a hearing was held in juvenile court and the juvenile court decided that Arbeiter should be tried as an adult.

Missouri's Seventy-Fifth General Assembly amended the juvenile code after the Arbeiter case to make "inadmissible in criminal proceedings" all admissions, confessions, and statements by the child to the juvenile officer and juvenile court personnel. Even though the amendment came after the actions in Arbeiter, the court decision was essentially the same result.

By declaring inadmissible statements Joe Arbeiter made to the juvenile officer in this case and throwing out Joe's confession (and the evidence gathered as a result of that confession) to the police in the earlier appeal that led to the retrial, the court ruled that the state did not have enough legally admissible evidence of the defendant's guilt. Joe Arbeiter, although he had admitted murdering an innocent Nancy Zanone, would be free in as little as two weeks if the state declined to retry him.

A *St. Louis Globe-Democrat* editorial calling for juvenile court reform said, "Joseph Arbeiter is free—not because he was declared innocent but because of the fact that he was only 15 at the time of the 1963 slaying. He boasted to

police, 'I'm only 15 years old. They can't do anything to me.' Tragically, his prophecy has proven correct."

Brendan Ryan, the same assistant circuit attorney who had listened to Arbeiter confess and saw no emotion in the boy as he did so, had moved on to become circuit attorney. He believed that changes were needed in the juvenile code, perhaps a lowering of the age limit or an exemption for certain crimes. "In order to protect the juvenile and society in such serious cases perhaps the treatment of juveniles as adults should begin as step one… right after their arrest."

The state's request for a rehearing or a transfer of the appeal to the Missouri Supreme Court en banc (to be heard by the entire court) was denied, ending measures available to the state to keep Arbeiter behind bars. Less than three hours after that final decision was handed down, Joseph Arbeiter walked out of prison a free man.

Circuit Attorney Brendan Ryan said, after examining the supreme court decision, "We have not enough legal evidence on which to try Arbeiter again."

12

A SISTER GOES TO WORK

The reversal was slammed in the media, particularly the *St. Louis Globe-Democrat*. That paper ran an editorial on January 13 with the headline "Arbeiter Case Mocks Justice."

"Something is terribly wrong with the machinery of justice when a convicted murderer such as Joseph Arbeiter is released from prison on a legal technicality," the editorial read. "The law should be for the protection of those who abide by it. When confessed killers, because of their age, are able to use legal technicalities as a shield from prosecution for violating the law, justice has broken down. The Arbeiter case is a sickly comment on current social values."

The paper ran another editorial headlined "Justice Strangled" on February 11, 1970. "The bizarre case of Joseph Franz Arbeiter is irrefutable evidence of the need for drastic changes in Missouri's Juvenile Code," the editorial said. "As this 1957 law now functions it is a mockery of justice.

"Arbeiter is a confessed killer.... Yet today Joseph Arbeiter walks the streets a free man, his jail cell door opened by a legal technicality.

"If ever there was a miscarriage of the legal process this is it. Justice has been strangled by a loophole in the law, which will continue to victimize society until the statute is corrected."

The news of Joseph Arbeiter's release was a horrible blow to the family of Nancy Zanone. The wife's, daughter's and sister's murderer was walking the streets.

Slaying in South St. Louis

The Zanone children were beginning to find out, in bits and pieces, what had happened to their mother. Their Grandmother Love kept a scrapbook of the murder, the trials and the appeals. On the rare (and becoming rarer) occasions the children spent time with her and their grandfather, she allowed them to look through the scrapbook—much to their father's dismay. Laura especially remembers looking at it, as do the Gruenenfelder cousins (the children of Nancy's sister, Joan). The cousins, Julie and Carrie, spent more time with the Love grandparents, and the scrapbook was always present. They were fascinated, not frightened, by it. It was an ordinary activity to look at it with their grandmother. Carrie and Julie remember always being aware of what had happened to their Aunt Nancy.

Their mother, Joan Gruenenfelder, Nancy's younger sister, was devastated, first by her sister's murder, then again when her murderer was set free. She could no longer sit back and do nothing. Joan and Jane Pahl formed an organization they called ACT: A Challenge Today. The purpose was to do exactly what the newspaper editorials called for—move forward with changes in Missouri's juvenile code and increase safety for the citizens of the state.

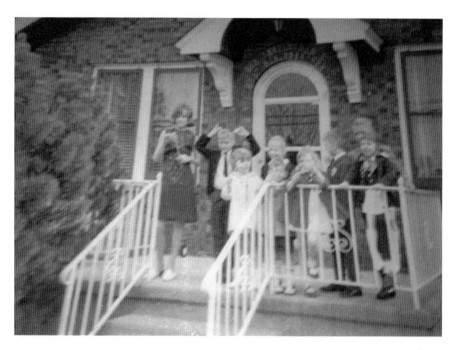

Laura and David join their cousins at the Gruenenfelder home on Easter after Nancy's death. Shown are (*left to right*) Christi Jost, Paul Jost, Greg Jost, Laura, David, Julie Jost, Julie Gruenenfelder (Joan's daughter) and Carrie Gruenenfelder (Joan's daughter). *Zanone family.*

Jane Pahl was a cousin of Joan's husband, Thomas. After Nancy's death, she became a surrogate sister to Joan. People even thought they looked like sisters. Jane had always been politically active and was a motivating force behind Joan taking on political activism to deal with her frustration with the way her sister's killer had been dealt with.

At the time she began her crusade to change juvenile laws, Joan was a twenty-eight-year-old homemaker and mother of three small children. Her sister's death had an enormous effect on her. It made her hyperaware of safety (doors were always locked for the remainder of her life). Worst of all, Joan became an only child. She had no one with whom to share memories of her childhood or take part in the care of her aging parents. Mrs. Love had suffered a nervous breakdown in the turmoil of Nancy's murder and had become even more dependent on prescription drugs. This meant that Joan also had less and less of her mother to rely upon. There was no one on the other end of the telephone when Joan wanted to talk to her sister. Even Nancy's children, her niece and nephew, were becoming more distant with their move to North County and entry into their new family. Joan's children also regretted the loss of their cousins and playmates.

Initially, Joan and Jane decided that the best way to attack the problem was to create buttons with "ACT" on them, speak to groups and educate people about the juvenile justice system and its shortcomings and carry out a petition drive seeking changes in the juvenile code.

Jane said in their drive to overhaul the system, "We're not taking any rights away from the juvenile but we feel this is giving society more consideration." [It seems based on the Arbeiter decision that] "all the rights have been going to juveniles."

Joan said, "But it is not for vengeance, because what we are doing will not affect him [Arbeiter]. It is the future we are looking to."

The women toured juvenile facilities around the state and concluded that the facilities were being "misused." The facilities housed runaways rather than juvenile offenders. Their study of facilities determined, in their minds, a need for a maximum security facility for juveniles, although this was not included in the legislation Pahl and Gruenenfelder eventually proposed.

In the beginning, the women concentrated on St. Louis and St. Louis County, collecting nine thousand signatures on their petition. They made speeches to local groups and appeared on local television. (Joan's children remember coming home for lunch on school days to watch their mother on TV. They thought she was a star!)

Joan Gruenenfelder began her move to change the juvenile code with this simple button. ACT stands for A Challenge Today. *Gruenenfelder Collection.*

Joan and Jane were effective speakers. After a speech to the Lindenwood Homeowners Association (Lindenwood is a neighborhood in south St. Louis City), the association decided to send a resolution to all members of the Missouri General Assembly, asking the legislature to revise the juvenile code because the present code "resulted in fostering crime rather than protecting the public." The resolution said in part, "the crime problem in the Nation has become acute," that it was rooted in "the ranks of irresponsible youth of our nation" and that the juvenile code that was enacted "to protect youth against abuses of the laws…has provided means of subterfuge instead." The resolution went on to say, "mindful of the inequities indicated through the results accomplished in the Arbeiter case," it "implores the legislature to change the Juvenile Code."

Eventually, the ACT campaign moved beyond St. Louis. Joan and Jane wrote to every newspaper in the state of Missouri and asked them to print the petition and pertinent background information about the juvenile system and the proposed legislative changes. September 14, 1970, kicked off official petition week, and mail poured in. Carrie Gruenenfelder Spencer remembers her parents sitting at the kitchen table, counting names. Eventually, the tally of signers reached more than twenty-three thousand.

The petition read:

> *WE, the undersigned, particularly in view of the present decline in respect for law and order and rapidly rising rate of juvenile delinquency and the apparent inability to deal with the latter under the Missouri Juvenile Code, as witness the recent Arbeiter case, strongly urge the next regular session of the Missouri General Assembly to make drastic and far-reaching changes in the Missouri Juvenile Code to provide more adequate methods for detection, detention, and correction of juvenile offenders.*

After the petition drive calling for changes in the code was a success, Joan and Jane moved forward, presenting their proposed changes to state legislators by initiating lobbying efforts in Jefferson City.

During this period, the news media constantly referred to Joan Gruenenfelder and Jane Pahl as "south St. Louis housewives," or "the most attractive lobbyists frequenting the halls outside the House and Senate chambers," or "a pair of pert housewives with six young children between them" rather than two politically active women trying to promote changes they fervently believed in that would "put a little common sense into the law, strengthen the Missouri Juvenile Code—put some teeth into it," as Joan Gruenenfelder said.

The women proposed six changes to the juvenile code:

> *That the juvenile court judge be given the power to commit a mentally disturbed child to an institution until mentally sound rather than end the confinement automatically at age twenty-one.*
>
> *That a juvenile taken into custody be advised of his rights and taken before juvenile authorities within twenty-four hours instead of immediately. Any confession or evidence taken within that twenty-four hours would be admissible in adult court so long as the juvenile was advised of his rights.* [The present law required the juvenile to be taken immediately before the juvenile court.]

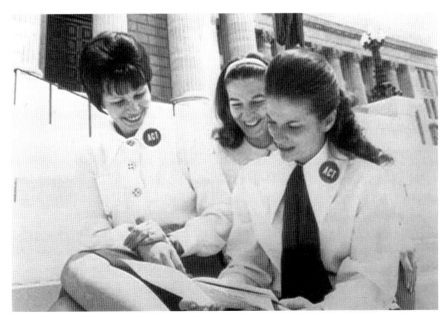

Joan Gruenenfelder (*left*), an unidentified supporter of ACT and Jane Pahl (*right*) were dubbed "perky housewives" instead of serious lobbyists when working toward changing the juvenile code. *Gruenenfelder Collection*.

A juvenile, age fourteen and over, suspected of a "serious crime" (murder, rape, armed robbery, kidnapping, arson, bombing) or showing "a definite increasing crime pattern" requires a judge to hold a hearing to decide if the juvenile should be tried as an adult. [Judges had the option of whether or not to decide to try a juvenile as an adult.]

Eliminate the "band of secrecy" surrounding juvenile court proceedings.

Once a juvenile is certified as an adult, the jurisdiction of the juvenile court ends. [Opponents said this was the case under the code at the time.]

If a defense attorney is present in a juvenile court proceeding, the proceeding should be conducted in an "adversary atmosphere," meaning that the prosecuting attorney should be able to help present evidence against the juvenile.

Once the ACT proposals were on the table, Joan and Jane began to spend time—up to three days a week—in Jefferson City, courting legislators. Joan and Jane laughed at being called lobbyists. They joked that they wasted a lot of time in the beginning "lobbying" other lobbyists until they figured out who was who.

Some bills based on the propositions promoted by ACT were presented to legislators. Representative John Blassie, a Democrat from St. Louis, was a supporter of ACT. He offered a bill that eliminated the law that required police to take juveniles immediately to a juvenile officer upon arrest. Under his bill, the child would be advised of his right to counsel and could be held by the police for up to twenty hours. Also, any voluntary confession by the juvenile—in the presence of a lawyer—could be used against the juvenile. Evidence seized by the police during that time could also be used when presenting a case.

Other bills provided the following changes:

A commissioner be appointed (in metropolitan areas, meaning St. Louis and Kansas City) to decide if a juvenile age fourteen to seventeen should be tried as an adult if the offense the juvenile was accused of would be a felony if committed by an adult

Permitting the prosecuting attorney to present evidence to juvenile court judges

Allowing a juvenile committed to a mental institution to be kept there until released by the court even if beyond the age of twenty-one

Justice Denied for Nancy Zanone

> *Automatically prosecuting any juvenile fifteen years and older as an adult if the crime the juvenile was accused of involved murder, forcible rape, armed robbery, kidnapping, arson or bombing.*

There were, of course, opponents. Joseph Arbeiter's father repeatedly harassed Joan Gruenenfelder with phone calls at all hours. He demanded she stop her work because it was bringing his son back into the spotlight. It became so bad that the Gruenenfelders had to change their number to an unlisted one.

The *Jefferson City Post Tribune* called the proposed legislation "four bills weakening the rights of juveniles accused of crimes."

Joan Gruenenfelder felt very strongly that the proposals took no rights away from juvenile offenders. Instead, their rights, under the current law, were secured at the expense of tools available for the prosecution to obtain convictions. "We want a law that will protect both kids and society," she said. "Our amendments wouldn't hurt the good kids. We're after the sophisticated, aggressive juveniles."

Furthermore, Joan felt that crime victims were unrepresented in court proceedings of juveniles who committed violent crimes. "You have a social worker, a defense lawyer and a judge who are supposed to be supportive of the child," she said. "There is no one to represent you or me."

David Zanone, the son of murder victim Nancy Zanone, after reading the trial proceedings as an adult, felt the same way. He considered that his mother, the victim, was no more than a prop in the court case.

Judge Theodore McMillian, who was serving as juvenile court judge at the time of the pending legislation, countered Mrs. Gruenenfelder's statement that no one represents the victim. "The public is represented through the judge—I am elected."

One of the main objections to Gruenenfelder's and Pahl's work was that it was based on an emotional response to a few cases. Would the opponents and media make the same criticism if the proposals came from male lobbyists rather than "a pair of pert housewives?" Joan was always up-front and honest about the fact her activism stemmed from a personal experience.

Another objection to the components of the proposal was that they concerned prosecution only, ignoring rehabilitation. This was especially true of the provisions dealing with trying juveniles as adults and the police holding juveniles for a period of time before turning them over to the juvenile authorities. Both Judge McMillian and Judge Noah Weinstein of the St. Louis County Juvenile Court disagreed with ACT

Theodore McMillian was serving as juvenile court judge and opposed many of the changes Joan Gruenenfelder and Jane Pahl proposed to the juvenile code. *Missouri State Archives.*

that trying more juveniles as adults would be better for society. The juveniles certified as adults were often acquitted, they pointed out. And, if convicted as an adult, the juvenile would go to prison without rehabilitation and would be eventually returned to society. Weinstein said that locking up the wrongdoer is a temporary solution to decreasing crime. The increase in crime was due to lack of rehabilitation. And the juvenile court was more successful at rehabilitation than was the penal system.

Judge McMillian believed that the current juvenile code allowed him to decide cases on what would be best for the child, to "focus on the actor rather than the act."

As far as the police holding the juvenile for a period of time and being permitted to use any information (confession or evidence) obtained during that time, Judge McMillian said, "A major purpose of the [Juvenile] Code is to ensure that there can be a relationship of trust between juvenile officers and the kids. If the juveniles knew that statements to court personnel were admissible, they'd never say anything."

The opponents also contended that the juvenile code in no way hampered police investigations. The police could testify about any statements made by the juvenile from the time he was picked up until he was turned over (immediately) to the juvenile court.

As far as appointing commissioners to determine whether a juvenile should be tried as an adult for certain more serious crimes, those who opposed the bills said that commissions are probably more softhearted than the ACT proponents believe. And, such appointments would also constitute an illegal delegation of judicial power.

On the issue of removing the "band of secrecy," those opposed to the reforms believed publicity could, based on the child involved, either create a desire for even more attention by creating a "star" and increase the likelihood of the child committing further crimes or stigmatize the child within the community.

In the course of the legislation passing one house or another and being changed along the way, a provision on lowering the age definition of juvenile to fifteen was also introduced and supported by ACT. This provision was criticized as being contrary to the age definition in most states and the national recommended standard. The judges felt that lowering the age would write off too many young people who commit bad acts because they are socially and/or emotionally immature and brand them as felons for life.

The final, damning opposition stated that making such far-reaching changes in the juvenile code would turn back time to when there was no special court for juveniles and eliminate special consideration for them, treating juvenile wrongdoers simply as common criminals.

Along the way, as bills affecting the juvenile code passed the house or the senate, some legislators said the changes would protect the public from "dirty, rotten outlaw kids," while the opponents said they would wreck the Missouri Juvenile Code. When the first bill passed the house, an unnamed lobbyist told Joan and Jane, "Well, girls, now you're one of the boys."

Passing the house and the senate were varying versions of bills that changed the juvenile code. The bill went to a committee to work out a version that would pass both houses of the legislature. The senate passed that bill and rushed it, on the last day of the 1972 legislative session, to the house.

Despite eighteen months of hard work and finally being tagged "one of the boys," Joan and Jane were still not assured their bill would pass. And it didn't. On that last day, it died.

Joan Gruenenfelder was pregnant with her fourth child by that time. She'd missed seeing her youngest daughter take her first steps. It was time to hang up her lobbyist hat and return home to her family.

Later in life, Joan returned to school and became a paralegal, probably influenced by her legislative work, daughter Carrie Gruenenfelder Spencer says. Jane Pahl moved away from Missouri and continued to be active in political work until her health declined.

Although their mother was often out of the house during those eighteen months of ACT, both her daughters, Carrie and Julie, agree that, regardless of the fact they don't remember specifics, it was a positive experience to grow up watching their mother fight for something she believed in.

13
AND THEN JOE...

Joseph Arbeiter was twenty-one years old when he was released from the Missouri State Penitentiary. Though granted a second chance, it was one Arbeiter soon squandered.

After leaving prison, Arbeiter moved back in with his mother and younger sister. While Joe was in jail, his mother had married a truck driver named James Randazzo.

Living in a ranch home in south St. Louis, the family was on edge about Arbeiter's troubles. Shortly after his release from jail, a reporter from the *St. Louis Globe-Democrat* visited the home; his arrival was not welcome. "Joe is in the basement," James Randazzo told the reporter, "and we've got nothing to say to reporters. And any reporter that comes around here is going to get his [censored by the newspaper] beat in, or worse."

Although Arbeiter did not speak with the reporter, Randazzo evidently settled down enough to speak and give some insight into Arbeiter's plans for the future. They were plans that harkened back to his teenage obsession: the military. "There's no future for Joe in St. Louis," Randazzo said. "It's best that he leaves town. He may even decide to make a career in the military."

Randazzo said that Arbeiter hoped to enlist in the U.S. Marines or U.S. Air Force and defended his stepson's growth. "Joe has changed. He has a different attitude, a different way of looking at things."

An army recruiter interviewed for the article said that Arbeiter's ambitions could not come to fruition. "He was twice convicted of murder and even

though the verdict was set aside the chances are that he would not be eligible for enlistment."

This seemingly did not deter Arbeiter.

"You see, Joe doesn't really have a record," Randazzo said. "He was convicted illegally and he was freed."

It is unknown how serious Arbeiter was about joining the military; perhaps he attempted to enlist at some point. What is certain is that he never served in the armed forces. Also evident is that Arbeiter, contrary to what Randazzo claimed, did not actually change.

Arbeiter's first re-acquaintance with the law took place June 15, 1970, less than six months after his release from prison. He was arrested on traffic charges in south St. Louis County. He was originally pulled over for failing to dim the headlights on his car, then was found to be driving without a license. Arbeiter told the police he "did not have a driver's license and…he had never had a license."

A mere eleven days later, he was in far more serious trouble. Arbeiter apparently attended a party the evening of June 26, a Friday night. The party was hosted by a twenty-one-year-old woman. After the guests left the party, the woman alleged, Arbeiter returned and raped her. He also allegedly threatened to kill her if she reported the attack.

The woman said Arbeiter returned to her home on June 30, this time with a gun (it is unclear if he was armed during the initial attack). When the woman refused to let him in, Arbeiter fired a shot into the house. He was arrested on July 1, booked on the rape charge, suspicion of shooting into an occupied dwelling and destroying property.

Arbeiter was indicted on the rape charge on July 16, 1970, and returned to jail while awaiting trial.

The trial took place in early 1971. Arbeiter's defense produced a witness, seventeen-year-old Edith Pullen, who said she was with Arbeiter in Doniphan, Missouri (a small town in southern Missouri and a three-hour drive from St. Louis) on the date the attack was alleged to have occurred. She said they were visiting her parents; the girl's parents corroborated her testimony.

After two hours of deliberation, the jury acquitted Arbeiter of the charges, and he was free once again. It would be only a short time before he ran afoul of the law again.

On June 1, 1971, a knife and cigarette lighter were stolen from the home of Roy Miller, who lived in the 3500 block of Missouri Avenue in St. Louis. That same day, a car was stolen from the 3500 block of Washington Avenue.

Two detectives spotted the car in the 2100 block of Pestalozzi Street (notably, the girl who provided Arbeiter's alibi in the February rape trial lived in the 2000 block of Pestalozzi) around three o'clock that afternoon. The detectives noticed that Arbeiter was at the wheel, with another man in the passenger seat. The license plates on the car were registered to Arbeiter, though the detectives knew the car was not the type he owned.

The detectives stopped Arbeiter for questioning and found the knife and cigarette lighter. The next morning, two warrants were issued for Arbeiter's arrest on charges of second-degree burglary and operating a motor vehicle without the owner's consent.

David and Laura Zanone happened to be visiting their Zanone grandparents when the police showed up to tell them that Arbeiter had been arrested and would be, in their opinion, returning to prison. David remembers feeling confused, unhappy that the man who had killed his mother was still around committing crimes yet, for the first time, he, David, having some concrete knowledge of Arbeiter's criminal wrongdoing. Laura also had a sense that they were finally going to learn more about what had happened. But, that didn't happen. Don continued to "protect" his children.

At the time, the multiple charges seemed routine, but they would eventually lead to another incredible stroke of luck for Arbeiter, one with tragic consequences for others.

Arbeiter was granted a change of venue for his trial on the grounds that "residents of the city were prejudiced against him." The trial was moved from the City of St. Louis to St. Louis County.

The change of venue turned out to be unnecessary. On October 12, 1971, Arbeiter pled guilty to the charges. He was sentenced to six years in prison, according to the *St. Louis Post-Dispatch*. More specifically, he was sentenced to four years on the burglary and car-theft charges and two years for concealed-weapons charges (the concealed weapon in question being the knife he had stolen from Miller). The sentences were to be served consecutively—that is, after serving the four-year sentence for burglary and car theft, he would serve the two-year sentence for the weapons charge.

That is not what happened.

Arbeiter was released from prison on August 1, 1974, with less than three years of his sentence served. This would not have been unusual for a four-year sentence. According to Mark Steward, an administrative assistant to the director of Missouri's Department of Corrections, state law dictated that prisoners serve three quarters of their sentence, minus time off for good behavior.

The confusion, however, sprang from whether the four-year and two-year sentences were consecutive or concurrent. The four-year term was, in fact, three concurrent sentences (for burglary, stealing and operating a motor vehicle without the owner's consent). Steward told the *Post-Dispatch* that the penitentiary records showed only that Arbeiter had been sentenced to two concurrent four-year sentences for burglary and stealing.

Inmates began their journey to prison at the circuit clerk's office and were then turned over to the St. Louis County Welfare Department for transport to the penitentiary. A review of circuit clerk records showed the correct sentence for Arbeiter: four years plus a two-year sentence to follow. This showed that the records made it at least as far as the welfare department. Somewhere between there and Arbeiter's arrival in prison, though, the paperwork for the second, shorter sentence was lost.

Had Arbeiter integrated into society successfully, the early release could be written off as a simple mix-up. However, Arbeiter had already shown himself incapable of doing so.

This continued when, on September 14, 1974, just over a month after his release from prison, Arbeiter allegedly entered the Artesian Lounge in Herculaneum, Missouri, roughly a half hour south of St. Louis, after it was closed (early reports refer to the bar as the Martinique; the majority call it the Artesian, so that is what is used here). The Artesian had been a popular nightspot in the 1960s, with guests including Ike and Tina Turner stopping by. By the 1970s, however, it was home to a "rough crowd."

Louis "Jack" Hasty, the tavern's owner, and a female companion entered the tavern shortly after Arbeiter. The female went straight to the restroom. While there, she heard the sounds of a scuffle, then shots. A man in a ski mask opened the bathroom door and forced the woman out, where she saw Hasty laying on the floor, shot. The man then forced the woman to perform a sex act on him. He restrained the woman by tying her to a chair and taping her eyes while saying Hasty "was a fool for fighting with someone with a gun. It was a shame I had to kill him."

Arbeiter was arrested at his mother's home in Arnold, Missouri, the next day. Police said Arbeiter said nothing during the arrest. "He wouldn't make any statements of any kind," Walter "Buck" Buerger, the sheriff of Jefferson County, said. "He wouldn't comment on anything. He's been through the mill before."

Jefferson County lieutenant Bimel Wheelis added that Arbeiter "wouldn't even tell you his name."

Arbeiter was held without bond in the Jefferson County jail at Hillsboro.

Justice Denied for Nancy Zanone

David Zanone was living in Hazelwood at the time with his father, sister and stepfamily. One of his jobs was to take out the trash. A newspaper lay on top of the trash open to the story about Arbeiter murdering again. David left the paper on top of the trash and revisited it, rereading the story every night until the trash was picked up. The man who had killed his mother was still killing.

During the pretrial hearings, the woman was unable to identify Arbeiter as the man in the ski mask. Police and prosecutors took hair samples from the ski mask and from Arbeiter in an attempt to connect the two. They also focused their case on a fingerprint matching Arbeiter's that was found on a broken pool cue. The woman testified that the man in the ski mask threatened to stab her with the broken end of the cue.

Joseph Arbeiter as an adult in the 1970s. During this time, Arbeiter was tried and acquitted of the murder of Jack Hasty in Herculaneum, Missouri. *Photo by T.V. Vassell,* Globe-Democrat Collection, *St. Louis Mercantile Library.*

Arbeiter's attorney again argued that his client could not get a fair trial in the St. Louis area. The judge ordered the trial moved to Jackson County, on the far western side of the state which includes Kansas City and most of its Missouri suburbs. The trial commenced on January 14, 1976.

Two days later, Arbeiter was found not guilty of the murder and sodomy charges; the jury deliberated for less than an hour before returning its verdict. He was held in prison anyway, on the basis of failing to complete his two-year sentence on the weapons charges from 1971.

Later that year, Arbeiter sued the state, claiming that the time he spent in jail while awaiting the murder trial should have been credited to the two-year sentence he was serving. In February 1977, a judge rejected Arbeiter's suit, ruling that "state prisoners did not have the legal right to demand that time spent in jail be subtracted from a prison sentence."

Despite the ruling, Arbeiter was released from the Missouri State Penitentiary on March 10, 1977. This time around, he was able to stay out of trouble for a relatively long period, though that did not mean he was a model citizen.

Julie Gruenenfelder, Nancy Zanone's niece, was a sophomore in high school around this time. She took a bus to school, making a transfer near a

donut shop at the intersection of Hampton and Southwest Avenues in south St. Louis, where Arbeiter was living.

A man sitting in a white car became a regular presence outside the donut shop where Julie made her transfer. One day, Gruenenfelder overheard two women talking; one said "the sad thing is, she doesn't even know he's watching her." She asked the women if they were talking about her. They said they were; the man had been there for months, trying to look up Gruenenfelder's uniform skirt. When she wasn't there, the man just left.

Gruenenfelder told her mom, who parked across the street the next day to keep an eye on the man who watched her daughter. She took down the license plate number of the white car and tailed it for a bit before losing sight of it. She reported the incident to the police.

The day after that, several police cars parked near the donut shop. The man drove his car into the shop's parking lot and made eye contact with Gruenenfelder, who looked at the police. The man left immediately, never to return.

Joan Gruenenfelder later told her daughter that the man who had been watching her was Joseph Arbeiter.

Also during this time, Laura Zanone graduated from Hazelwood West High School and married for the first time. Her husband was in the U.S. Marines, and they moved to North Carolina. Laura's son was born in 1980. Laura was moving forward with her life.

Arbeiter managed to avoid arrest for nearly two years. He, like Laura, also married during this quiet period. On June 4, 1978, he wed Shirley Newcom in St. Louis. It would still be another year before his name would appear in the newspaper again.

Even then, his offense was minor. Arbeiter was arrested in Cahokia, Illinois, (across the Mississippi River from St. Louis) on charges of stealing a candy bar and a bag of peanuts from a Quickway Foods convenience store in June 1979. The total value of the stolen items was $1.44. Arbeiter posted a $35.00 cash bond and was released.

The name "Joseph Arbeiter" again disappeared from the newspapers and police blotter for over two years, though he was evidently dealing drugs during that period.

Gary Hummert, a police officer in the St. Louis Police Department, pulled Arbeiter over for failing to stop for a red light at Gravois and Ohio Avenues. Hummert found a bag of marijuana stuffed behind the backrest of the driver's-side seat.

Hummert said he remembered thinking Arbeiter's eyes were "very cold and scary looking."

It would not be the last time Hummert and Arbeiter were involved in a drug case; in fact, the second time would lead to Arbeiter's longest-served prison sentence.

Beginning in early 1981, police put Arbeiter under surveillance when "known drug users" were seen frequenting his residence on Missouri Avenue, a block of square brick homes. On August 15 of that year, a neighbor told police officers that Arbeiter was selling drugs out of a cooler in front of his residence. The neighbor also said that a man with Arbeiter was armed with a concealed .45-caliber handgun.

The officers told their watch commander and attempted to notify the narcotics detectives, though Hummert said they were told that the detectives didn't work weekends.

Officer Thomas Neske wrote up a search warrant for Arbeiter's residence, which was signed by Judge Robert Dowd.

Eight patrolmen surrounded Arbeiter's home. Several went to the alley behind his home in their cars; others, including Hummert, approached the front of the home. Two officers, including Bart Rey, Hummert's partner, forced open the front door. They were met by Larry Melton, a relative of Arbeiter's wife, wielding a knife. Melton attempted to stab Rey, who fired a shot. Melton dropped the knife.

Upon entering the residence, officers proceeded to Arbeiter's bedroom, with Arbeiter offering no resistance. Hidden in the headboard of his bed and also in other areas of his bedroom, the officers found $10,000 worth of marijuana, codeine, pentazocine (a heroin substitute that, combined with tripelennamine, became known as "T's and blues" during the 1970s) and propoxyphene (a narcotic suppressant). Officers also noted that numerous knives were embedded in the stone foundation along the headboard of Arbeiter's bed.

Arbeiter was charged with four counts of possession of a controlled substance and held in lieu of a $15,000 bond, which was eventually posted. His housemate was charged with displaying a deadly weapon.

Although Arbeiter offered no resistance during the raid on his home, he evidently planned to escape before he could be convicted. Before his trial on the drug charges in June 1982, an informant told police that Arbeiter's mother-in-law, Vernice Melton, was going to bring a gun into the courtroom to give to Arbeiter. The plan was for Arbeiter to disarm the courtroom deputy and kill Judge Daniel Tillman.

According to Carrie Gruenenfelder Spencer, who worked in the prosecutor's office at the time and is the niece of Nancy Zanone, Tillman was a "tall, no nonsense in my courtroom kind of a man." Courthouse chatter was that when a guilty verdict was returned in a serious felony trial, Tillman stood behind his chair with his hand tucked under his robes, holding the butt of a gun.

When Tillman heard of Arbeiter's plans to smuggle a gun into his courtroom, he revoked Arbeiter's $15,000 bond. True to his reputation, according to Officer Hummert, Tillman also armed himself with two pearl-handled .45-caliber handguns. Tillman told the *St. Louis Globe-Democrat* that rumors circulated that Arbeiter had told others "he would never return to prison—that he would take some people with him in the courtroom if he had to go. I don't take lightly to people threatening to shoot up the courtroom."

Arbeiter was strip-searched and placed in a cell. A deputy was posted outside the courtroom to search all who entered. Upon encountering the deputy, Vernice Melton admitted to having a teargas gun in her purse. She claimed the gun was "evidence she was bringing to Arbeiter's attorney." The prosecuting attorney said the gun had no connection to the case; officials ordered Melton to give the gun to Arbeiter's attorney. She was not charged.

The trial lasted three days. Arbeiter was found not guilty on the counts of possession of codeine, Librium and another painkiller. According to the *Globe-Democrat*, "the jury did not believe that the prosecution proved that Arbeiter knew how to use each drug."

On the counts of possession of marijuana and possession of pentazocine, Arbeiter was found guilty. Judge Tillman sentenced Arbeiter to the maximum ten years on each count, a total of twenty years in prison. The jury, unfamiliar with Arbeiter's history, was stunned.

Arbeiter's drug dealing was apparently a family business. In June 1983, almost exactly a year after Arbeiter went to prison, St. Louis police arrested fifteen middle-level drug dealers as part of an eight-month undercover operation. Among those arrested were Arbeiter's wife, Shirley, who was charged with ten counts of sales of pentazocine, hydromorphone (synthetic morphine) and valium. Shirley Arbeiter was on probation for passing bad checks at the time.

Arbeiter's stepfather, James Randazzo, who had threatened reporters shortly after Arbeiter's release from prison in 1970, was also arrested in the operation. He was charged with three counts of the sale of pentazocine.

Later that year, Arbeiter appealed his conviction on the drug charges. His appeal largely centered on a claim that the police couldn't have known that the bedroom he was found in was actually his. He offered four specific arguments in an attempt to overturn his sentence.

Arbeiter's first claim was that the informant who told police of Arbeiter's drug activity was never identified. The court of appeals ruled that

> *the informant's identity would* [not] *have been helpful to the defense or proved the defense's innocence. Defendant…was charged with possession and not sale of controlled substances. The informant did not witness defendant's possession of the substances and defendant has failed to produce any evidence or arguments which would persuade us to believe this informant's identity was necessary to secure useful testimony or in any way was crucial to his defense. In fact, defendant only argues disclosure is required because the informant was the only one with personal knowledge that the bedroom was his. Our review of the record reveals this is not the case and that there was sufficient evidence to establish the bedroom was in fact the defendant's.*

Arbeiter also argued that he should have been granted a mistrial when one of the arresting officers testified that it was the informant who told him that the bedroom in which the drugs were found was Arbeiter's. During the trial, the judge sustained the defense's objection to this piece of testimony and ordered the jury to disregard the statement. Arbeiter wanted the judge to go one step further.

This point, too, was refuted by the appeals court, which said, "We do not believe Officer Conner's statement was so prejudicial that the trial court's admonition to disregard it would not cure any prejudicial effect. Officer Conner had already testified he had personal knowledge that the defendant was coming from the bedroom in question."

Examples of cases that had been declared a mistrial on the grounds of prejudicial statements were included in Arbeiter's appeal, but the court found that "our review of these cases revealed highly prejudicial situations where clearly inadmissible statements were admitted or where statements constituted an invasion of the accused's constitutional rights. All are clearly distinguishable from the instant case where we believe the trial court cured any prejudice which may have resulted from the statement."

The third argument presented to the appeals court was that there was insufficient evidence to establish Arbeiter's possession of the controlled

substances. Arbeiter's argument was that "there was joint control of the bedroom by defendant and his wife"; that is, that the drugs were his wife's and he knew nothing about them.

While the appeals court allowed "there is room for the possible hypothesis showing defendant's innocence," it ruled that "it is not reasonable. The quantity of drugs found in the bedroom coupled with the evidence establishing defendant's presence and right to control the premises again was sufficient for a jury to determine that defendant had knowingly and intentionally possessed the drugs."

Arbeiter's final attempt to wiggle away from his jail term concerned the sentence he received. He had been sentenced under the Persistent Offender Act, which, Arbeiter argued, was "inapplicable to drug convictions." He also claimed, falsely, that he had been convicted of only a misdemeanor.

Arbeiter also argued that he should have been sentenced by the jury and not the judge. The court ruled that because Arbeiter "was a persistent offender it was within the court's power to sentence the defendant and not the jury's."

Having been denied his appeal, Arbeiter set back to work on finding another way to escape his sentence. In August 1987, Arbeiter filed another appeal of his drug conviction. In this appeal, Arbeiter requested "an evidentiary hearing to determine the validity of his contention that the trial judge improperly considered [his] overturned murder convictions in imposing the maximum sentence." This was denied, as the court said such questions were a matter for direct appeal, not for appellate review.

Arbeiter also argued that "the trial judge had taken prejudicial security measures at trial." Again, the court denied the argument, saying that was a matter for direct appeal. Arbeiter would serve his sentence.

While Arbeiter spent the longest stretch of time in prison that he would face during his life, the Zanone children continued to move forward. David graduated from Hazelwood West High School and attended the University of Missouri in Columbia, eventually receiving a master's degree. He went to work for the State of Missouri and, in 1990, married Brenda Berger. They had one child, Kyle, in 1995.

Laura divorced her first husband and returned to Missouri with her son, Matt. In 1987, she married for a second time. Steve Maedge had a son, Ryan, close to the age of her son. It was almost like having twins, she says. The boys grew close, becoming best friends as well as stepbrothers.

As Laura prepared to marry Steve, she began to come to terms with what had happened to her mother, partly due to talking with Steve about it. When the wedding was coming up, Laura dreamed for the one and only time of her mother. Nancy helped Laura adjust her veil and then disappeared. When Laura awoke, she had a feeling of well-being, that everything would be okay.

Arbeiter served the entirety of one of his ten-year terms, not leaving prison until 1992. Upon his release, he was able to stay out of serious trouble for a period of about two years. In 1994, he violated his parole and was sent back to prison from 1994 to 2002. He then had the longest period of his adult life as a free man.

Being out of prison, however, did not mean he had no encounters with law enforcement. After prison, Arbeiter evidently decided that St. Louis was no longer the place for him. He moved to Sedalia, Missouri, about ninety minutes east of Kansas City.

He avoided the police there for years, until he was arrested for misdemeanor possession of marijuana on February 27, 2008. Arbeiter, sixty years old at that point, pled guilty to the crime. He was fined $400 and sentenced to one year in prison. However, the judge suspended the prison sentence, instead placing Arbeiter on probation for a period of two years.

During those two years, Arbeiter moved to the Goodwill Chapel Trailer Park, about four and a half miles from the Pettis County Courthouse in downtown Sedalia. His probation ended in March 2010; he made it through with no infractions but would not get through the calendar year without another criminal charge.

On November 28, 2010, forty-seven years to the day that he committed his first violent offense—the stabbing of Grace Munyon in St. Louis—Arbeiter, again driving without a license, was involved in a car accident. He left the scene—a felony under Missouri state law.

The Sedalia police arrested him, and in May 2011, Arbeiter pled guilty to the charges. He was sentenced to four years in prison, but again the sentence was suspended. A five-year probation period was substituted.

This allowed Arbeiter to remain at the trailer park, where he committed his final crime. On April 30, 2014, Arbeiter was arrested for allegedly raping a resident of a neighboring trailer.

While he was in custody, maintenance workers at the trailer park began cleaning his trailer to prepare it for another rental when they found a metal

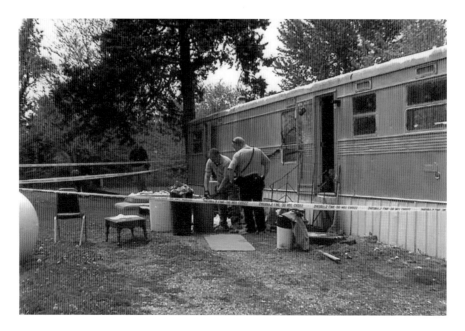

Police search Joseph Arbeiter's trailer in Sedalia, Missouri. Maintenance workers found human remains in the trailer while cleaning it after Arbeiter was arrested on rape charges. *Fox4kc.com.*

box with two human arms inside. Authorities were notified and additional remains were found in shallow graves in the woods near Arbeiter's trailer.

Facing a first-degree murder charge that would likely have brought the death penalty, Arbeiter pled guilty. He admitted that he had killed a woman (he said he did not know her name, "only that she went by 'Mandy'") in early 2014. Authorities estimated that the woman was killed around January 1, 2014.

Like Nancy Zanone, this victim was stabbed multiple times. Arbeiter then dismembered the body, an attempt to conceal his crime.

The victim was a thirty-five-year-old woman from Marshall, Missouri, named Mandy Black. (Black would have been thirty-six at the time her remains were discovered but was believed to have died before her March birthday). She was the mother of four boys. According to her obituary, she enjoyed the outdoors, fishing and hunting for rocks and arrowheads.

After pleading guilty, Arbeiter was sentenced to life in prison for murder in the first degree and armed criminal action.

Upon learning of the Sedalia murder, Don immediately called David and Laura. The news media was already trying to talk to him, and as every time

Justice Denied for Nancy Zanone

Left: Mandy Black was Joseph Arbeiter's final victim. She was thirty-five years old at the time of her death. *Rea Funeral Chapel, Sedalia, Missouri.*

Right: Joseph Arbeiter, then sixty-five, pled guilty to the murder of Mandy Black and was sentenced to life in prison. He died six months into his term. *Pettis County Sheriff's Department.*

before, Don refused and urged the children (now adults) to do the same. Even without the family's cooperation, the news media rehashed Nancy's murder on television, in the newspaper and now online as well.

During this time, David was working in his yard when a local television station's van pulled up. He had already prepared a press release because of the attention the media was paying his father. He, too, refused to be interviewed. Because Laura's last name was different, the press could not locate her.

At this point, David needed to know more. Laura had nursed an anger for most of her life that Arbeiter had never had to pay for murdering their mother. David called the prosecuting attorney in Sedalia and asked if the conviction was a sure thing. So many times before, it had seemed to be, only to turn out not to be. The prosecutor said he wanted to go for the death penalty but, because of Arbeiter's age, would exchange a life sentence for a guilty plea.

David and Laura attended the trial, mostly for information but also to finally see this man who had such a momentous effect on their lives. The siblings agree that all this imagined monster turned out to be was an old, drugged-out man.

Joseph Arbeiter's final prison sentence was short. He was incarcerated at the Crossroads Correctional Center in Cameron, Missouri. On June 20, 2015, he died of natural causes in a Columbia, Missouri hospital.

Donald Zanone still won't talk about the murder. David and Laura don't want to ask him questions because of the feelings it will bring up. They are protecting each other.

EPILOGUE

My sister and I entered the Pettis County Courthouse on a cold, dreary December day to witness the pleading and sentencing of Joseph Arbeiter to rape, murder and drug charges. Almost fifty-one years to the day had passed since we last crossed paths with "Joe," as he was known. The Missouri Supreme Court gave him a new lease on life on charges of murdering our mother because of procedural errors by law enforcement. The court's ruling gave him a second chance, one not afforded my mother, but Joseph chose to follow the wrong path. As a result, here we were, another life lost to his hands, another life unalterably damaged, two more families left to pick up the pieces.

Joseph Arbeiter was only a name to me most of my life. I knew what he did, that he was young at the time, that he didn't fully pay for his crimes, but I'd never seen a picture and didn't know anything else about him. So I did what most would do, I built an image of him in my mind. As a child, I created a decidedly sinister character, one easily identifiable as evil. I imagined he had dark piercing eyes, an evil smirk and a nasty disposition whose countenance betrayed to the world the demons that lurked deep inside. When his latest crimes were publicized, many of the newspapers printed a picture of Joseph as a well-groomed teen, complete with neatly combed hair and a soft, innocent face. The picture revealed none of the dark images that were dancing through his head, thoughts that led him to hide in the shadows of our back door, waiting patiently to plunge a knife into a loving mother of two. He looked so normal. Without much thought, I

Epilogue

had to go to his pleading and sentencing to see for myself just what kind of monster Joseph Arbeiter was.

The door to the courtroom opened, and his orange-clad body entered, shuffling under the weight of shackles and loose-fitting prison sandals. His face was worn and wrinkled, his gray matted hair pushed behind large, round ears. He kept his head down, staring at the floor just in front of him as he shuffled toward his seat. I studied him as he slowly walked from the door, past the judge's bench, directly toward me, sheriff's deputy by his side. His face revealed nothing as he turned and sat with his back to us, sitting straight in his chair awaiting the arrival of the judge. He showed no outward sign of emotion and offered no gesture that I could point to and say, "Aha! You are a monster." He wasn't grandfatherly, as someone his age might seem to me. As he whispered occasionally to his attorney, he appeared to be unaffected by the prospect of life in prison. I wasn't horrified by his presence, as I thought I would be. But I couldn't help but stare at him. He seemed so unremarkable, a fact that disarmed me. But I kept searching for some sign of the evil I knew he had to be.

The judge asked him the standard series of questions. Did he understand why he was here? Did he feel he received good counsel? Did that counsel explain to him all of his options? He answered "yes" to each question in a calm, even voice. Then, the judge began to ask him how he would plead to each of the charges. One by one, he answered them without hesitation, confirming his guilt. "I did," he admitted in the same unburdened tone. He offered no explanation, no justification, no excuse—and, more strikingly, no remorse. He didn't care. He felt nothing. He did what he did: drugs, rape, murder, mutilation.

The image of his ordinariness perplexed me and remained on my mind long after we left the courtroom. I needed time to process what I'd just witnessed. Who was this beast? I thought long about what I'd read about December 2, 1963, and studied the trial transcripts. There was nothing out of the ordinary about his behavior that fateful day, either. Passersby saw an ordinary, unassuming fifteen-year-old boy walking down the street. They thought nothing of him. The woman who answered the door up the street thought the encounter odd but nothing more. My sister was unalarmed as he asked whether our mom was at home. He stood on our front stoop casually, attracting no attention. He nonchalantly eased into the house, moving carefully through the living room toward the back bedroom, disturbing nothing. He quietly slipped into the shadows of our bedroom next to the kitchen, waiting for my mother to come up from the laundry. He stood there

Epilogue

David Zanone and Laura Maedge in 2017. *Author photo.*

and listened to her footsteps as she walked up the stairs, anticipating her arrival at the door. He clutched his knife. She entered the house and shut the door behind her. Joseph could have run, but he stood there, patiently waiting for the back door to latch. And then at the click of the jamb, he exploded into a violent rage.

The psychiatrists in the trials all described Joseph as a troubled boy who idolized an abusive father, feared women, hated his mother and fantasized that one day he would become a superhero. They described him as reciting my mother's murder dispassionately and that he only became emotional when confronted with questions about his own dysfunctional family. The more I thought about it, the closer I came to understanding. "Therein lies his ruse," I thought. The calm, outwardly normal person I observed in the courtroom was no different than the monster who murdered my mother. In fact, he has always been the worst kind of monster imaginable: evil cloaked in a veil of normalcy. Joseph Arbeiter was the kind of monster you don't recognize…until it's too late.

<div style="text-align: right;">David Zanone</div>

BIBLIOGRAPHY

Baldwin, Carl R. "Huge Caseloads Overburdening Youth Officers." *St. Louis Post-Dispatch*, March 7, 1965.

Cincinnati Enquirer. "An Object Lesson." Editorial. July 22, 1970.

City of St. Louis, Missouri, marriage license (1978), Joseph F. Arbeiter and Shirley Y. Newcom. Office of the Recorder of Deeds, St. Louis City.

Colt, John V. "Drive to Reform Juvenile Code at Halfway Point." *St. Clair (MO) Chronicle*, September 17, 1970.

Constantin, Angelo. "Man Freed After 2 Convictions Held in Killing." *St. Louis Globe-Democrat*, September 16, 1974.

Daily Capital News. "Twice-Freed Arbeiter Arrested on Murder Charge." September 17, 1974.

Fields, Larry. "Arbeiter's Dream: To Enlist in Army." *St. Louis Globe-Democrat*, February 28, 1970.

Flach, Tim, and Robert Lucken. "Arbeiter Freed by Mistake, Authorities Say." *St. Louis Globe-Democrat*, September 17, 1974.

———. "Officials Still Have No Answers in Early Release of Arbeiter." *St. Louis Globe-Democrat*, September 18, 1974.

Geist, Ted. "Juvenile Code Issue: Safer Street or Rehabilitation?" *St. Louis Post-Dispatch*, December 13, 1970.

———. "Urges Toughening State Juvenile Code." *St. Louis Post-Dispatch*, April 14, 1972.

Gruenenfelder, Julie. Email interview with author. June 2017.

Bibliography

Gruenenfelder, Mrs. Thomas (Joan) and Mrs. Alan (Jane) Pahl. "An Answer." Letter to the editor. *Daily Capital News* (Jefferson City, MO), May 22, 1971.

Hummert, Gary. Interview with author. May 3, 2017.

Jefferson City (MO) Post-Tribune. "Conviction of Youth Reversed by Court." January 12, 1970.

Joseph Arbeiter v. State of Missouri, 738 S.W.2d 515 (1987).

"Korean War Project." http://www.koreanwar2.org/kwp2/usa/2id/go/USA_2ID_GO_1952_338-350.pdf.

Leeman, Wayne. "Continues Hearing on Murder." *St. Louis Post-Dispatch*, October 11, 1974.

Lindecke, Fred W. "Panel Sets Aside Bill on Juvenile Confessions." *St. Louis Post-Dispatch*, March 29, 1972.

———. "Senate Passes Youth Crime Bill." *St. Louis Post-Dispatch*, June 10, 1971.

Love, John. "From the Father of Nancy Zanone." *St. Louis Globe-Democrat*, January 6, 1964.

Lucken, Robert. "'Lost' Arbeiter Records to Be Delivered to State." *St. Louis Globe-Democrat*, September 21, 1974.

Maedge, Laura Zanone. Interview with author. May 13, 2017, June 26, 2017; email exchanges February, May, June, August and September 2017.

Major, Carl. "Police to Ask Change in Law on Juveniles." *St. Louis Globe-Democrat*, December 2, 1966.

Mann, Jennifer S. "Human Remains Found on Property of Man Whose Life Sentence in St. Louis Murder was Overturned." Stltoday.com, May 6, 2014. www.stltoday.com/news/local/crime-and-courts/human-remains-found-on-property-of-man-whose-life-sentence/article_f181ffed-f372-5c65-865c-4f1e7f1cad80.html.

O'Neil, Tim. "A Look Back. St. Louis Factory Loaded America's Weapons during World War II." Stltoday.com, June 27, 2010. www.stltoday.com/news/local/metro/a-look-back-st-louis-factory-loaded-america-s-weapons/article_3485624f-ef86-51ee-b100-858060b47c9f.html.

Rogers, Kathryn. "Court Guard Finds Tear-Gas Weapon." *St. Louis Post-Dispatch*, June 11, 1982.

Rose, Louis J. "Arbeiter Wins Reversal." *St. Louis Post-Dispatch*, January 12, 1970.

———. "Prosecutor to Get Arbeiter Case Data." *St. Louis Post-Dispatch*, April 8, 1968.

———. "Retrial Ruled for Arbeiter in Fatal Stabbing." *St. Louis Post-Dispatch*, October 10, 1966.

Bibliography

———. "State Seeks Rehearing on Arbeiter Decision." *St. Louis Post-Dispatch*, January 14, 1970.

Rosenbaum, Connie. "On Juvenile Code." *St. Louis Post-Dispatch*, March 10, 1972.

Ryan, Brendan. Interview with author. June 15, 2017.

Schafers, Ted. "Officials Review Juvenile Code." *St. Louis Globe-Democrat*, December 3, 1966.

Sedalia (MO) Democrat. "Arbeiter Dies While Serving Life Sentence." June 22, 2015. www.sedaliademocrat.com/news/754/arbeiter-dies-while-serving-life-sentence.

Sheppard, Margaret. "Youth Granted New Trial in Slaying of S. Side Woman." *St. Louis Globe-Democrat*, October 11, 1966.

Spencer, Carrie Gruenenfelder. Email interview with author. June 2017.

Springfield Leader and Press. "Young Housewives Pushing for Juvenile Law 'Teeth.'" February 18, 1971.

State of Missouri v. Joseph Franz Arbeiter, 408 S.W.2d 26 (1966).

State of Missouri v. Joseph Franz Arbeiter, 449 S.W.2d 627 (1970).

State of Missouri v. Joseph Franz Arbeiter, 664 S.W.2d 566 (1983).

State of Missouri vs. Joseph Franz Arbeiter. Trial transcript. January 4, 1966.

State of Missouri vs. Joseph Franz Arbeiter. Trial transcript. May 8, 1969.

St. Clair (MO) Journal. "Arbeiter Case Basis of Petition." March 26, 1970.

St. Louis Globe-Democrat. "Arbeiter Arrested on Car Theft Charge." June 2, 1971.

———. "Arbeiter Back Where He Belongs." July 20, 1970.

———. "Arbeiter Case Hurries Shift of Work among Youth Officers." December 5, 1963.

———. "Arbeiter Case Mocks Justice." January 13, 1970.

———. "Arbeiter Defense in Motion to Kill Evidence." December 20, 1966.

———. "Arbeiter Evidence Admissibility Argued." August 1, 1968.

———. "Arbeiter Freed on Bonds after Traffic Law Arrest." June 17, 1970.

———. "Arbeiter Hair Sample Ordered." October 11, 1974.

———. "Arbeiter Indicted, Charged with Burglary, Stealing." June 26, 1971.

———. "Arbeiter Is Acquitted in Club Owner's Slaying." January 17, 1976.

———. "Arbeiter Is Indicted On Charge of Rape." July 17, 1970.

———. "Arbeiter Now Charged with Rape." July 3, 1970.

———. "Arbeiter Released; Murder Term Upset." February 10, 1970.

———. "Arbeiter's Bond Set at $200,000." February 21, 1975.

———. "Arbeiter's Murder Trial to Start in Kansas City." January 13, 1976.

———. "Confession in Bus Driver Slaying Barred." November 17, 1966.

Bibliography

———. "Discussion to Be Held on Effect of Arbeiter Ruling." December 1, 1966.
———. "Dowd Expects Drop in Crime Solutions." November 30, 1966.
———. "15 Arrested On Drug-Dealing Charges." June 16, 1983.
———. "Good and Bad Juvenile Code Revisions." Editorial. June 14, 1971.
———. "Joseph Arbeiter Charged with House Burglary." June 4, 1971.
———. "Joseph Arbeiter Charged with Rape of Woman, 20." July 2, 1970.
———. "Joseph Arbeiter Wins Rape Charge Acquittal." February 3, 1971.
———. "Justice Strangled." February 11, 1970.
———. "Juvenile Records Asked for Arbeiter Retrial." January 6, 1967.
———. "Murder of Justice." Editorial. September 17, 1974.
———. "New Charge Is Peanuts for Old Hand at Crime." June 26, 1979.
———. "Official Scores Juvenile Code Proposal." December 4, 1970.
———. "Open the Arbeiter File." April 10, 1968.
———. "Ruling Gives Access to Arbeiter Records." April 9, 1968.
———. "The Shield of Youth—Only 15 Years Old." December 5, 1963.
———. "Slain Woman's Sister to Talk on Juvenile Code Reform." November 28, 1970.
———. "Slayer Arbeiter Will Be Tried as an Adult." December 31, 1963.
———. "State to Decide Soon on Move for Rehearing in Arbeiter Case." January 13, 1970.
———. "They Can't Do Anything to Me." December 31, 1963.
———. "Tighten Juvenile Code, Arbeiter Case Kin Says." March 26, 1970.
———. "To Curb Juvenile Crime." Editorial. December 9, 1963.
St. Louis Post-Dispatch. "Arbeiter Acquitted in Killing Trial." January 17, 1976.
———. "Arbeiter Arrested in Burglary." June 2, 1971.
———. "Arbeiter Arrested in Rape, Shooting." July 1, 1970.
———. "Arbeiter Arrested on Traffic Counts." June 16, 1970.
———. "Arbeiter Boy Found Guilty; Life Sentence." December 12, 1964.
———. "Arbeiter Case." Editorial. October 27, 1966.
———. "Arbeiter Case Advanced." February 21, 1975.
———. "Arbeiter Case Rehearing Asked." January 21, 1970.
———. "Arbeiter Case Witness Tells of Hearing Shots." January 15, 1976.
———. "Arbeiter Cleared of Rape Charge." February 3, 1971.
———. "Arbeiter Given Change of Venue." October 5, 1971.
———. "Arbeiter Hearing Delay." October 14, 1974.
———. "Arbeiter Is Arraigned in Another Killing." September 16, 1974.
———. "Arbeiter Is Indicted in June 26 Rape Case." July 17, 1970.
———. "Arbeiter Is Sentenced to 6 Years for Burglary." October 13, 1971.

Bibliography

———. "Arbeiter Loses Early Release Suit." February 20, 1977.

———. "Arbeiter Says He Already Served Term." December 2, 1976.

———. "Arbeiter's Statements to Police Barred." January 5, 1967.

———. "Arbeiter II." Editorial. April 12, 1968.

———. "Arbeiter III." Editorial. January 14, 1970.

———. "Arbeiter Trial Opens." January 14, 1976.

———. "Arbeiter Trial Shifted." August 6, 1975.

———. "Arbeiter Youth to Be Tried as Adult in Killing." December 30, 1963.

———. "Boy, 15, Admits Killing Woman; Decision Due On Trial As Adult." December 4, 1963, 1–12.

———. "Boy in Killing Never Brought Before Judge." December 4, 1963, 1–12.

———. "Change in Police Treatment of Juvenile Suspects Urged." October 17, 1966.

———. "Charged After Drug Raid at Home." August 17, 1981.

———. "Corcoran Backs Judge's Order on Juveniles." November 10, 1966.

———. "Court Backs Arbeiter." February 9, 1970.

———. "Decision Monday on Trying Joseph Arbeiter as Adult." December 27, 1963.

———. "'Dirty Rotten Kids.'" Editorial. June 14, 1971.

———. "Effect of Ruling on Juvenile Cases Said to Be Exaggerated." December 3, 1966.

———. "Homicide Verdict in Stabbing by Boy." December 6, 1963.

———. "Housewives Near Goal of Tighter Youth Code." June 13, 1971.

———. "Judge Declares a Mistrial in Arbeiter Case." October 28, 1964.

———. "Judge Says Policy Strains Juvenile Center." April 4, 1967.

———. "Judge Seeks One Responsible for Arbeiter's Early Release." September 17, 1974.

———. "Juvenile Code Change Urged by South Group." April 15, 1970.

———. "Killer Dies in Prison." June 24, 2015.

———. "Man Seized in Drug Raid at Home." August 17, 1981.

———. "Motion for New Trial for Arbeiter Overruled." February 8, 1965.

———. "New Procedures on Juveniles Are Put in Effect by Police." November 17, 1966.

———. "Officials to Discuss Ruling in Arbeiter Case." December 1, 1966.

———. "Police and Juveniles." Editorial. November 5, 1966.

———. "Police and Juveniles." Letter to the editor. November 2, 1966.

———. "Police Cite Time Lost in Youth Cases." December 19, 1966.

Bibliography

———. "Police Juvenile Set-Up Criticized." November 30, 1966.

———. "Police to Seek Change in Law on Juveniles." December 2, 1966.

———. "Police to See Legal Opinion on Juveniles." October 26, 1966.

———. "Seeks to Void Confession in Arbeiter Case." December 19, 1966.

———. "Thoughts on Arbeiter." Editorial. February 15, 1970.

———. "Tighter Juvenile Code Advances." March 10, 1971.

Thompson, Ruth Ellen. "Arbeiter Heads Back to Prison—For 6 Years." *St. Louis Globe-Democrat*, October 13, 1971.

———. "Court-Appointed Lawyers Ask Fees." *St. Louis Globe-Democrat*, November 8, 1968.

Thornton, Edward H. "Judges Say New Bills Threaten Juvenile Code." *St. Louis Post-Dispatch*, March 4, 1971.

Weather Underground. "Weather History for KSTL—December, 1963." www.wunderground.com/history/airport/KSTL/1963/12/2/DailyHistory.html?req_city=&req_state=&req_statename=&reqdb.zip=&reqdb.magic=&reqdb.wmo=.

Wiethop, Deborah. "Man Is Found Guilty in Narcotics Case." *St. Louis Globe-Democrat*, June 11, 1982.

Williams, Marie. "Juvenile Code." *Sunday News and Tribune* (Jefferson City, MO). Letter to the editor. May 16, 1971.

Winn, Daniel. "Sedalia Admitted Killer Has Lengthy Criminal History." *KMIZ*, May 21, 2014. www.abc17news.com/news/crime/sedalia-admitted-killer-has-lengthy-criminal-history/53907160.

Zanone, David. Interviews with author. May 13, 2017, June 26, 2017 and email queries in February, April, May, June, August, September 2017

Zanone, Donald. Interview with author. June 26, 2017.

INDEX

A

A Challenge Today (ACT) 106, 107, 108, 110, 111, 112, 113
Arbeiter, Joseph
 Appeals 80, 81, 101
 Childhood abuse 38, 40, 41
 Confession 53, 55, 58, 70, 72, 91, 93
 Knives 37, 40, 42, 43, 75
 Mental health 42, 43, 66, 73, 74, 75, 76, 77, 78, 93
 Stealing 37, 40, 41, 43, 44
 Subsequent crimes 116, 118, 120, 121, 125, 126
 Truancy 37, 40, 41, 43
Arbeiter, Joseph Sr. 37, 38, 39
Arbeiter, Shirley Newcom 120, 122
Arbeiter, Wilma 37, 41, 42, 44, 51, 54, 58, 73, 94, 115

B

Bantle, John 69, 70, 76
Bardgett, John 66, 88, 89, 90, 91, 92, 93, 94, 95, 96
Bergmann, Dr. John 75, 76
Black, Mandy 126
Buder, Judge William 88, 89, 90, 92, 93, 94, 95, 96, 101

C

Callahan, Dr. Joseph 76, 77, 78

F

Feldmeier, Sgt. Walter 51, 52, 53, 54, 67, 70, 91
Finnegan, James 66, 78
Fredericks, Henry 88, 89, 90, 91, 92, 93, 95, 96

INDEX

G

Gansloser, Quentin 55, 56, 58, 72
Gruenenfelder, Joan 13, 24, 106, 109, 111, 113, 120
Gruenenfelder, Julie 106, 113, 119, 120

H

Haley, Jana 73
Haley, John Jr. 66, 67, 69, 70
Hasty, Louis 118
Hellman, Dr. Daniel 77, 78
Hummert, Gary 120, 121

J

Jones, Donald 56, 58, 59, 92, 93, 94, 95, 101
Juvenile Code 66, 81, 82, 84, 87, 89, 101, 102, 103, 105, 106, 107, 108, 109, 112, 113

K

Keady, Officer John 49, 51, 54, 71, 72
Kilroy, Sgt. Michael 55, 72, 94
Kuelker, John 48

M

McMillian, Judge Theodore 83, 111, 112

McMullan, Judge David 61, 65, 66, 84, 101
Meirink, Dr. Thomas 47, 49, 90
Miranda case 72, 81, 84, 93
Munyon, Grace 43, 51, 52, 67, 69
Murphy, Judge David 69, 70, 71, 72, 73, 79, 80

O

O'Donnell, Officer Eugene 49, 51, 54, 55

P

Pahl, Jane 106, 107, 109, 111, 113
Police procedure 52, 54, 83, 84

R

Randazzo, James 115, 122
Rome, Howard 73, 74, 75, 76, 93, 94
Rosenberg, Dr. Marshall 74, 75, 76
Ryan, Brendan 55, 56, 103

S

Spencer, Carrie Gruenenfelder 108, 113, 122
Stocker, Detective Corporal Frank 51, 52, 54

Index

T

Thomas, Betty 47, 48, 70, 71, 91

W

Walsh, Captain John 51, 52, 54, 55
Weinstein, Judge Noah 82, 111, 112

Z

Zanone, David 29, 34, 35, 50, 70, 85, 97, 99, 111, 119, 124, 126, 127
Zanone, Don 16, 19, 20, 32, 49, 50, 70, 71, 85, 90, 97
Zanone, Laura 29, 34, 35, 48, 49, 50, 70, 85, 88, 97, 99, 106, 117, 120, 124, 126, 127
Zanone, Nancy
 Dance 13, 19, 22
 Death 47, 48, 49, 50
 Relationship with Don Zanone 16, 19, 20, 21, 22, 23, 24, 28, 29

ABOUT THE AUTHORS

Photo by Robin Frisella.

Vicki Berger Erwin is the author of more than twenty books ranging from picture books to adult, fiction and nonfiction works. Vicki worked in various segments of the book industry for twenty-five years, including owning an independent bookstore. She lives in St. Louis with her husband, Jim, who is also an author for The History Press.

Bryan Erwin works as a software tester by day. His short fiction has appeared in multiple journals. He lives in St. Louis with his wife, Sarah, and two kids.

Visit us at
www.historypress.net